Edwa Betts

D1241637

Books by the same author

A CHRISTIAN LOOKS AT THE JEWISH QUESTION
A PREFACE TO METAPHYSICS
AN INTRODUCTION TO LOGIC
AN INTRODUCTION TO PHILOSOPHY
ANGELIC DOCTOR (Saint Thomas Aquinas)
ART AND SCHOLASTICISM
FRANCE MY COUNTRY
FREEDOM IN THE MODERN WORLD
LIVING THOUGHTS OF SAINT PAUL
PRAYER AND INTELLIGENCE (with Raïssa Maritain)
RANSOMING THE TIME
RELIGION AND CULTURE
SAINT THOMAS AND THE PROBLEM OF EVIL
SCHOLASTICISM AND POLITICS
SCIENCE AND WISDOM
THE DEGREES OF KNOWLEDGE
THE RIGHTS OF MAN AND NATURAL LAW
THE THINGS THAT ARE NOT CAESAR'S
THREE REFORMERS: LUTHER, DESCARTES AND ROUSSEAU
TRUE HUMANISM
TWILIGHT OF CIVILIZATION
EDUCATION AT THE CROSSROADS

ART AND POETRY

JACQUES MARITAIN

ART AND POETRY

Translated by
E. de P. Matthews

PHILOSOPHICAL LIBRARY
NEW YORK

Printed in the United States of America
by F. Hubner & Co., Inc. for Philosophical Library, Inc., N. Y.

PREFACE

PREFACE

The subject of this book is art and poetry, and the inter-
mingling of the human and poetic demands in man. Critique
and philosophy (sometimes theology) meet half-way in such a
work. When it was written, some of the artists with whom it
deals, for example Rouault, Chagall, or Lourié, had not yet
attained the brilliant and legitimate renown which they enjoy
today.

The first chapter is dedicated to three painters: Marc Chagall,
Georges Rouault, and Gino Severini. The second—entitled "Dia-
logues"—is but the continuation, in written form, of some
Parisian conversations and controversies; the interlocutors—
André Gide for instance, François Mauriac, Jean Cocteau, Charles
Du Bos, and some others—are present, as it were, behind the
scenes, their voices being heard through their own works or
writings, with which the readers addressed by the author are
supposed to be familiar. Thus an undercurrent of allusion to
the themes of the time runs all through this essay, without (at
least this is my hope) making it more than a little obscure. The
third chapter is concerned with the problems of poetry as the
spirit of our arts or as the creative source of the artist's work-
ings, especially in music, and with that freedom which is but a
gift of the spirit, in artistic productivity as well as in human
life.

In my book *Art and Scholasticism* I intended to consider the
essentials of art rather than the nature of poetry. Later on it

was this mysterious nature that I became more and more eager to scrutinize. The second French edition of *Art and Scholasticism* (of which the English translation has been made) contained a new chapter entitled "The Frontiers of Poetry." In the third edition, this new part was separated, in order to constitute a new book, complemented with the three chapters which are now being published in English in the present volume. To tell the truth, the latter presupposes in some way this essay, "The Frontiers of Poetry," which may be found in the English translation of *Art and Scholasticism* and which therefore could not be reprinted here. Suffice it to recall that in the essay in question I started to indicate the advantage that our modern concern about the inner and spiritual sources of art may find in using the classical theory of the Creative Idea, as elaborated by the theologians of old. With regard to poetry, considered as a "divination of the spiritual in the realm of the senses, to be expressed in the same realm," I formulated the following views: "Metaphysics," I wrote, "also pursues the spiritual, but in a very different way, and with a very different formal object. Whereas it keeps to the line of *knowledge* and the contemplation of truth, poetry keeps to the line of *making* and the delight procured by beauty. The difference is capital and not to be overlooked without prejudice. One snatches at the spiritual in an idea, by the most abstract intellection; the other glimpses it in the flesh, by the point of the sense sharpened by the mind. One enjoys its possession only in the secluded retreat of the eternal regions; the other finds it at every cross-road where the singular

and the contingent may be met. Both seek a super-reality, which one attains in the nature of things, and the other is content to touch in any symbol whatsoever. Metaphysics pursues essences and definitions, poetry every form glittering by the way, every reflection of an invisible order. The one isolates mystery in order to know it, the other, through the harmonies it constructs, handles and makes use of mystery like an unknown force . . . Poetry in this sense is clearly not the privilege of poets. It forces every lock, lies in wait for you where you least expect it. You can receive the little shock by which it makes its presence known, which makes the distance still recede and unrolls the horizon of the heart, as much when looking at any common thing, a paste-board model, 'silly pictures, door-mantels, stage decorations, back-cloths in the booths of a fair, sign-boards,' as when con-templating a masterpiece.

> *You read prospectuses and catalogues and the*
> *placards shouting aloud:*
> *Here's your poetry this morning . . .*[1]

"The *Fine Arts,* however, and the art of the poet itself, being ordered to a transcendental world, are specially designed by na-ture to bring poetry into our midst. Their desire is to seize it. When they meet it, they attain the principle of their own spirituality . . . Poetry is to art what grace is to moral life. Poetry is the heaven of working reason."

Finally I should like to do away, as far as possible, with certain misinterpretations which might occur, owing to the fact

[1] Guillaume Apollinaire.

that my positions on poetry and poetic knowledge are not explicitly stated in this book, but in another, which has not appeared in English.[1] I hope that what lies in the background of my reflections will be understood, namely the conviction that whereas poetry is, by its nature, working in the lines of art, poetry and poetic knowledge nonetheless infinitely transcend art merely conceived as the craftsman's virtue. The main task of the philosopher, in such matters, is to discern and revere the genuine substance that poetry conveys to us, and the freedom it aspires to, and the original, irreducible mystery of poetic knowledge. If he must insist, at the same time, that poetry has its own defined field and its frontiers, it is in order to assert its true nature; to point out the risks it involves, as does every grandeur, and which make poetry all the more worthy and lovable; and also to defend it against smugglers, killers and pseudo-prophets.

I am deeply indebted to Mrs. Elva de Pue Matthews for her faithful and delicately precise translation and I should like to express here my sincere gratitude to her.

J. M.

New York, April 1943

[1] *Situation de la Poésie*, par Jacques et Raïssa Maritain, Paris, 1938.

CONTENTS

13

THREE PAINTERS

To Emmanuel Chapman

MARC CHAGALL

When Saint Francis had wedded Poverty, he began to sing with unbelievable freedom the world's most delicate and newest song. He tamed the wolves, made a convent of birds, and in all unlikelihood and truth, his heart dilated with love, he took the air, afoot or on his mule out on the backs of what the Psalm calls the exultant hills.

Thus it is that Chagall weds painting; in all humility and cheer! His clear eyes see all bodies in a happy light, he delivers them from physical laws, and makes them obey the hidden law of the heart: agile, free, without heaviness, sagacious and eloquent as the ass of Balaam, fraternal, sweetened one toward the other, the pig toward the poet, the cow toward the milkmaid . . . A laughing gaze, sometimes melancholy, rummaging through an innocent and malicious world.

A quite real world however, like that of childhood. Nothing is firmer, warmer, more dovetailed, than the handclasp of the airplaning couple by which they hold one another up in the open air. Nothing reveals a truer knowledge of the animal world than these astonishing illustrations of the fables of La Fontaine that were to be admired at the gallery of M. Ambroise Vollard, in the fluid brilliance of which the good humor of the Ile-de-France mingles with the revery of Russian forests, La Fontaine with Kriloff and with the tales of Kota Mourliki.

On the visual plane everything looks topsy-turvy. In fact, on the spiritual plane a stroke of magical light has put every-

thing in place. Each composition of Chagall—a real discharge
of poetry, a mystery in the sanest clarity—has both an intense
realism and spirituality.

Occasionally he opens up his toys to see what is inside; this
because he loves them! He knows that in the brain of the cow
the little farmer-woman is sitting; he knows that the world is
capsizing around the lovers, bucolic and disastrous. He has won
the amity of creation, and parades his couples around the sky
with the assent of the little villages.

One asks one's self what knowledge, very sure and almost
painful in its perspicacity, permits him to be so faithful to life
in such complete freedom. No mistake can be made on the
love of things, of beasts, of the whole of reality—love too
nostalgic to be pantheistic—that animates such knowledge and
keeps it in good wind.

Now and then these reminders of Siennese profiles, of Floren-
tine visitations, make one feel the gravity that constitutes the
basis of so much fantasy, and understand the great love for
Angelico of this veritable and admirable primitive. Pitiful,
melancholic, haunted by the departure of perpetual wandering,
singing of poverty and hope, it is the very poetry of the Jewish
spirit that moves us so profoundly in these miraculous Rabbis,
as in the marvels of aerial mobility and fiery truth that spring
from the world of forms and colors invented by him for the
Yiddish Theater of Moscow.

At a time when the implacable creative force of a Picasso
and the pathetic genius of a Rouault would have sufficed, it

seems, to occupy all painting, we are grateful to Chagall for showing us that there are—so different, but not incompatible, for no beauty exhausts the multiple fecundity of art—still other sources of poetry. These hold fast in a singularly close manner to the lyricism of a race. But then, is it not a virtue already almost Christian—this taste for freshness and humility and difficult balances, for seeing the world thus from the angle of a happy catastrophe?

This obsession with miracle and freedom, with the innocence and a fraternal communication among all things reveals to us in Chagall an evangelical sentiment unconscious of itself and as if enchanted, where sometimes a certain grating of the world of the senses reminds us that here and there the devil still furtively shows his horns through the flowery bars of this luminous universe.

Chagall knows what he says; he does not perhaps know the range of what he says. That St. Francis would have taught to him, as to the larks.

(1929)

*

To illustrate the Bible was for Chagall's art a singular test. It remained to be seen whether that which seemed to some people only the exuberance of poetry and anxious tenderness, was not hiding a substance capable of being stripped bare . . . In truth those hardly doubted who had divined the importance of the heart in the paradoxes of this painting maliciously hastening to make all things embrace each other.

The forty etchings[1] executed for Genesis attest that the trial turned to the painters advantage. In remaining himself, he is renewed.

Reduced, concentrated, forgetful of the aggressive foliage of color and freedom, his art manifests the better that human and poetic quality and that depth of sentiment which makes him dear to us. Abstract without being cerebral, he does not use the burin methodically according to the procedure of the old masters. An ingenious technique, dictated by an ever alert sensibility, makes the white and the black and the black in the black sing wonderfully, with veiled modulations like the chanting of the Synagogue.

Certain Graeco-Buddhist sculptures have a strange family resemblance to the sculptures of the Christian Middle Ages. More Jewish than ever, Chagall rediscovers with his etchings, in a wholly other world, something of the grave and naïve mediaeval inspiration.

The difference however remains profound. In its highest perfection the Gothic succeeded in saving the intellectual purity of the Hellenic form by incarnating it in a universe of flesh and soul. The art of Chagall has nothing of the measure of Greek form, it stands at the extreme opposite.

It is from a sort of fluid chaos traversed by the soul that appear signs all the more moving since less self-contained and more engaged in the discords of matter, living appearances that are like the gestures of agile hands raised from below and beg-

[1] Now 105.—See *Chagall* by Raïssa Maritain (N. Y., Maison Française, 1943.)

ging pity. And here greatness appears at the same time, as in the descent of the Angels with Abraham or the angered solitude of Moses, or in that admirable Creation of Man, carried along with such noble movement.

It is in this sense that I said just now: more Jewish than ever. And still Chagall, in his etchings, has not *willed* to be Jewish, I suppose he does not even know very exactly which dogma, Jewish or Christian, the Old Testament illustrated by him proposes to us. It is the poetry of the Bible that he has listened to, it is this that he has wished to render, but this poetry is the voice of Someone . . .

I would reproach myself with seeming to solicit in any sense whatever an art which is thus religious only, so to speak, in spite of itself. It is so nevertheless, at least according to the most unformulated aspiration. And it is quite permissible to remark that precisely because he has sought and willed nothing in this sense, the plastic world of Chagall's Bible, so profoundly and dolorously terrestrial, as yet undelivered, and as if groping its way about in a sacred night, bears witness, without knowing it, to the figurative value of the great lyricism of Israel. The more Jewish is this world, and floundering among the laborious speculations of the three great Patriarchs who are the image of the three divine Persons, the more a nameless evangelical appeal mutely resounds in it. Look at the three Angels at the table of Abraham; what promises do they bring the old man from whom God can hide nothing because he is His friend?

(1934)

GEORGES ROUAULT

His pale complexion, his clear eye, always aware, but rather more inward-looking than fixed on the object, his violent mouth, bulged forehead, large skull once furnished with abundant blond hair (which it does not miss): there is here something of a moon-clown——a surprising blend of pity and bitterness, of malice and candor——in the physiognomy of this painter, enemy of coteries and of convention, and generally of all contemporary custom, whom renown is by way of drawing from his cave, for he was born in a cave in 1871, during the siege of Paris.

We know that Rouault, who learned first the art of the glass painter, entered when he was twenty the Ecole des Beaux-Arts, in the atelier of Gustave Moreau, of whom he was the favorite pupil. *"You haven't the brains to do as much,"* said Gustave Moreau to a member of the Institute[1] about a work of Rouault (the *Dead Christ,* now in the Grenoble Museum) which had been rejected at the *concours de Rome.* Thus did Rouault's career begin in storm . . . In the nobleness and fervor of his teaching as well as in his vivid intelligence about the past, Moreau was an exceptional master, still more exceptional in the pains he took to waken everyone to his true personality. Rouault has retained a piety for, a profound fidelity to his memory that are rare nowadays, and that alone can explain how such a savage could consent to occupy an official post (that of Curator of the *Musée Gustave Moreau*).

[1] Bonnat.

It is said currently that he has a *bad temper,* meaning an unsociable temperament. And in fact, relations with him are not always easy, at least for those ignorant of the fact that the sophisticated procedures of a delicate politeness are not the best way to approach him, nor for those also who, with assiduity always badly rewarded, amiably take the risk of asking him questions, asking him what he thinks of the new painting or the new poetry, where he spends his vacations, what he has on the stocks, what he paints with, and above all, ah above all: "I would *so* much like to see your latest work, couldn't I visit your studio?" That, that is the unpardonable. He buries in secrecy whatever concerns himself; whatever he is doing, he chooses to hide away like a wild thing. That is why he so rarely exhibits, why he is glad of the mercantile instincts of M. Ambroise Vollard, interposing a vast shadow between his works and the eyes of the profane.

In reality he belongs in the category of the shy explosives. Parisian through his mother, but Celtic and Breton through his father, he accumulates within himself, in the inexpressible regions of the heart, impalpable treasures of dream and of nostalgia, of suffering and azure, which the contact with others bruises and oppresses. He ceases to suffer violence only when he finds himself alone before the work to be created, or when he amuses and instructs his children,

> Geneviève mon gros bourdon,
> Isabelle ma colombelle,
> Agnès petit pigeon,

with wisdom and tenderness, with marvelous fantasy. His furies
and outbursts are not in the least understood unless they are
related to this interior lyricism, which, for several years now, he
has found need of expressing outwardly in weird songs, spring-
ing like wild flowers.

Along with this, a curious instinct for moral proselytism, a
natural incapacity for resigning himself to the mediocrity of
those about him; at bottom, an insatiable sympathy for human
things, prompts this recluse to enter into communication with
people and at the same time to get indignant at them. Under
the cover of bruskness, even of brutality, there hides a soul which
does not know indifference or disdain. Hence the ferocious
images, much more somber than the ordinary caricature, through
which, during one period (now long past) he had to discharge
his angered heart. His most violent exasperations against the
bourgeoisie and against our social order are thus like the disap-
pointments of a soul in love with an interior order that it wants
too avidly to meet in the streets, in the tribunals, and in the
subway.

The life of Georges Rouault not only offers a magnificent
example of disinterestedness, patient courage, furiously earnest
work, obstinate and without respite. It conceals profounder
virtues. When, as apprentice glassworker (he earned then 50
centimes a week, or about 10 cents), he had to carry a package
far, his employer gave him three sous (a little over ½ cent) to
take the omnibus. The child made the trip on foot, and kept
the 3 sous to buy paints; but in order not to rob his employer

even of a minute, he started along with the omnibus, and ran without stopping in order to arrive at the same time as the vehicle which was to have carried him. An astute combination, which adjusted the interests of art to those of probity, at the expense of cardiac muscles. We are pleased to see in this childish trait a symbol of the admirable moral rectitude, austere, scrupulous, heroic if there was need, of this great artist who still remains the artisan. There is in Rouault a *purity*—almost jansenist, and which could become cruel—that makes his force and liberty. There is also in him, like a living hidden well-spring, an intense religious feeling, the faith of a stubborn hermit, that led him to Huysmans and to Léon Bloy, and that made him discover the image of the divine Lamb in all the abandoned and the rejected whom he commiserates. It is religion that is at the origin of his tenderness and his revolt, of his hatred against all sorts of pharisaism. Add to this the faculties of a prodigiously sensitive eye, and the gift of pitiless observation, and you will understand the true meaning of his vehemences.

But first of all he is a painter, exclusively a *painter*. I do not refer to his technical knowledge only, nor to his disconcerting skill. I mean the spirit of the painting, in its most living intellectual and sensitive reality. A philosopher could study in him the virtue of art as in the pure state, with all its exigencies, its mysteries, its fierce self-restraint. If he wounds many people by reactions lacking in gentleness, if he protects himself against all modes of subjection with meticulous and vigilant violence, with umbrageous and proud independence, it is to maintain in

himself this virtue in its integrity. He likes to repeat after Poussin: "We are making a mute art" and while boiling always with a confused flood of thoughts, while possessing an exquisite sense of the beauty of the old masters and while finding sometimes the most significant sayings (design, he said, is a jet of the spirit on the alert) he never explains himself, letting his work alone defend itself, respecting his art to such a point that he does not wish to touch it by words. Obstinate in his furrow, he cannot be classed in any school. His painting, so human and expressive, has a purely plastic eloquence, with nothing literary in it. His love of rare materials, which could have led him astray in endless research, his human preoccupations and his taste for satire which could have diverted him toward anecdote—these he has not suppressed but dominated by his art, which, by triumphing over them, has become all the more pure and the more robust.

Seeing ahead of him, after his *Child Jesus among the Doctors*,[1] the easiest and most profitable future, he broke his moorings and scandalized his first admirers by entering the *dark night* of which he did not see the end, but where he felt his energies would be purified. Gustave Moreau, astonished by his first "realistic" experiments,—for they had begun at the time, with the butchers he saw passing in the rue des Fourneaux on their large wagons, then with the clowns whom he went to spy upon at the fête of Grenelle, when the parade ended, Gustave Moreau understood that after all it was better for him to follow his own

[1] 1894.—Now in the Museum of Colmar.

vision. But later his friends were to reproach him with failing at his task; at one moment very few refused to doubt him. I saw him, then, endure courageously several betrayals, and, what is harder to bear, the reprobation of true and faithful friends. Bloy, affectionately, but nonetheless mercilessly accused him of falling into a demoniac art, of delighting in ugliness and deformity. He listened motionless, white and silent. And what could he have answered? He was obeying a necessity of growth, stronger than he. Prostitutes, clowns, judges, shrews, it was himself that he sought, I mean his own interior accord in the universe of form and color. He has found himself; but that is a trail that one must blaze alone.

Patience! Impassioned as he has been by his art, Rouault has never hurried, either in order to succeed with the public and to obtain official sanction, or to *realize* all the potentialities that he had to lead to their point of unity. He has never done violence to his gifts. He has let the sap rise, the fruit ripen. Neither his vision nor his technique has suffered the repercussions of the passing styles. He knows the price of verve and of improvisation, but also the poverty of the facile, and of the false harmonies, that give pleasure for one season; the price of knowledge, but also the hollowness of virtuosity, of the recipes and amulets of the schools. He had a horror of an artificial order reconstituted by mechanical or imitative means; he has always felt himself claimed by a certain spiritual order linked to an exquisite measure, to fleeting nuances that have to be discovered from within.

He seized in the real, and made to flash forth for us a certain brilliance that none yet had thus discovered; these prostitutes and clowns, these monstrous miserable flesh-tints captured in the deaf harmonies and the precious transparencies of the most complex matter, this is the wound of Sin, this the misery of fallen Nature, penetrated by a gaze without connivance and an art that does not bend.

Hence this art of pathos has a profoundly religious meaning. For the religious quality of a work does not depend upon its subject but its spirit. Moreover, since the epoch when Moreau was named professor and head of an atelier at the Ecole des Beaux-Arts, which is to say since 1892, Rouault has painted religious subjects. He has always continued since then. His passing through the world of human abysses should not make us forget this essential orientation of his heart, this profound movement toward calm and clarity. Like his admirable landscapes, his religious work—and all the great production accumulated through thirty years of uninterrupted labor, paintings, ceramics, etchings, lithographs and so on,—has many surprises in reserve, even for those who have long followed his work.

(1924)

*

If a painter belongs, like the one in question here, to the family of the very great, it is by reason above all of his *poetics*. In every canvas of Rouault, the forms fill out the space—a unique space, arisen for itself—with a mysterious necessity akin

to that with which the natures of a universe fill out their boundaries.

But not by virtue of abstract recomposition is this accomplished. It is by the effect of a creative emotion provoked far down in the soul by the irritation of an infallibly sensitive eye and a profound imagination.

In so far as the word tradition relates itself to the maintenance and to the growth of certain values of humanity in artistic creation itself, the work of Rouault takes its place in the tradition of the masters. It is from the point of view of his poetic force that one can best discern the *quality* of his genius.

GINO SEVERINI

There is much groaning over the present epoch: "Art is no longer anything but artifice, acrobatics," etc., the great workmen of the past are bitterly missed; and when a man works and lives in their fashion, one is careful not to make much of him. What is mediocre today is not painting but criticism, it renders justice to an authentic primitive only if heaven, or the verve of Alfred Jarry has made him a customs inspector,[1] what wonder then that it has taken so long to recognize in Severini a true painter of the Italian Renaissance?

There are few stories so typical, rich in so instructive an artistic experience, as the story of Severini. The fellow-citizen of Luca Signorelli, of Pietro Berrettini and of Saint Margaret of Cortona, after having received the lessons of poverty, and learned to draw under the street lamps of Rome, debarked in 1905 in Paris—directly at a bar that was to become the Rotonde (let us admire this sense of the present!),[2]—a prey to his Italian youth, and to an aggressive, honest, and charming enthusiasm. He established himself on Montmartre where he knew Modigliani, Dufy, Utrillo, Braque, Picasso, Juan Gris. At one point he wanted to become an aviator and to drop painting for the beauties (which were to be remembered in his art) of mechanics and motion. In 1910, when his friend Boccioni decided (the fashion for manifestoes was beginning then) to ally himself

[1] It is known that in reality Henri Rousseau was employed in the toll-house of Paris.
[2] The Café de la Rotonde was to become, for some years, the most famous meeting place of the painters and poets of Montparnasse.

with the infant Futurism, and when Marinetti came to Paris to organize the crusade, Severini became one of the pillars of the futurist group—the only Parisian pillar; the others, Boccioni, Carra, Russolo and Balla, were in Italy. And Severini was that much more Parisian for marrying the daughter of the prince of poets, whom he met with Paul Fort at the Closerie des Lilas.

Nothing is so boring as painters' theories. This plethora of words is however not useless, it chokes off the mediocrities, and in deceiving a public opinion whose custom it is to be in the wrong, it permits the true creators, camouflaged by a gaudy philosophy, to produce according to their nature and their genius. Theories, like legends, contain besides, useful historic indications, transposed and deformed. At that time Futurism arrived in France like a fine transalpine access of impatience and generosity. Under the decoration of a Becoming and a universal co-penetration exceedingly Bergsonian, it manifested above all, along with a very poor spirituality, a candid return toward a nature not copied, but loved, and an animal joy in rolling itself in nature's colored floods. Apollinaire had not been wrong about this, and before striking up a friendship with the Futurists and trying to naturalize their tendences in Paris under the name of Orphism, he had begun by denouncing the "danger" of such a return to the *subject,* a danger above all to the reigning spirit.

If Futurism has not succeeded in implanting itself in France, it is doubtless that it clashed too violently with this spirit, and also that it was a thing too specifically Italian. "Our Italian nature," wrote Severini very justly, "has always prevented us

from considering art as a simple game, empty of content; on the contrary, the Italian falls very often into the fault of giving to the subject an importance that can injure his art; but that can become a great force also." It is certain however, that the Futurists exercised an influence perhaps a little too much un-recognized; as against Cubism, which they held to be a discovery of genius, but "depressing to the point of tears," they brought gayety, spontaneity, lyricism; not only did Severini get his sub-jects at the Bal Tabarin, as at the night clubs, and in modern machinery, but his canvasses themselves were dances of lines and colors. He was with Boccioni the best representative of Futurism, his renown was established from the time of the fu-turist exposition of 1912 in Paris and that of 1913 in London; he expressed himself with joy, with the ease of instinct; I retain a faithful admiration of certain of his works of that time, kaleidoscopic marvels of youth and color, which attain a true poetry; one attained in another fashion by the pictures inspired by the war which he painted several years later, in which the procedures of abbreviation and simultaneity dear to Futurism render with an astonishing intensity, and with the frankness of the best brightly colored pictures of Epinal, the spirit of in-exorable mechanization and destruction.

In theory, Futurism and Cubism were sharply enough op-posed. In reality a painter dreams first of all of enriching his art and his vision, and the intransigence of principles masks legiti-mate and practical collusions with the enemy. If some Cubists profited by the futurist contribution, the Futurists, and Severini

in particular, without renouncing their original bonds with Impressionism, knew enough to recognize the value of the anti-impressionistic reaction and to profit from its lesson. Also Severini had known Picasso and Braque before the institution of the cube system (much feared, as it is known, by these two great painters). And if he accused the Cubists of "nostalgia for the past" (*nostalgie passéiste*); if he reproached Picasso with seeking sources of renovation in Greek warriors and in the museums, if he was angered by Picasso's indifference on the subject and his will for a "pure painting"—"our Italian psychology," he said, "revolts against this gratuity, an art without subject is of an anti-Italian essence"—he understood nevertheless the importance of the reform conducted by Picasso, and he adopted for his own count, in a fairly large measure, certain of the fundamental ideas of this reform. One distinguishes here and there in the production of Severini a futurist period and a cubist period. In reality, he has since the beginning borrowed certain methods from Cubism. In spite of a return to Italy (1913-1914) that separated him regrettably from his friends in France, he had his part in the elaboration of Cubism in Paris.

However, with that absolute sincerity, pitiless toward himself—which, in artists where it exists to this degree, is a tragic element, and akin to a permanent temptation to despair that a great courage of the soul alone can turn into a permanent cause of victory and progress—Severini felt deeply the weaknesses of the double movement in which he participated. To proclaim the necessity of burning the museums, and to regard the created

world with a virgin eye, does not suffice to give the means of enclosing in a work that jealous reality which circulates through sensible forms. Neither does it suffice to conceive of a lofty goal, to recapture the primary reason of art, which is to construct, and create through the spirit, objects each one of which is a condensed universe existing for itself, it does not suffice to want to prepare an epoch of purity, of classical grandeur, in order to find again the poetic substance without which a fine work is never anything but a well-made corpse. Cubism was not upheld in reality except by the creative force of Picasso, that has become terribly plain with the years. Cubism and Futurism, the latter seeking the renovation of painting by the content and the matter of art, the former by formal discipline, had too great a lack of roots. Severini took the only path open before him to escape Cubism by going ahead of it, and applied himself with all his force, around 1917, to the apprenticeship of the *craft*. Was not Satie, a little late, to seat himself on the benches of the Schola?[1]

With the same generosity, and the same care for probity in the means, Severini began to interrogate the masters, to study all the treatises on painting he could lay his hands upon. He ran through and paraphrased many a treatise of architecture from Vitruvius to Viollet-le-Duc and Choisy. Having finally fallen upon the difficult constructions of Dürer, he initiated himself into the deciphering of them, into the mysteries of descriptive geometry and orthogonal projections; he made the acquaintance

[1] The *Schola Cantorum*, founded in Paris by Vincent d'Indy.

of Charles Henry—a dangerous encounter for an artist—
plunged into mathematics, into the study of numerical relations
and their analogy with musical sounds. This was an arid period
artistically, but very profitable, which lasted until about 1922.
Through the effect, of which the repercussions went a long way,
of his mathematical studies and the consideration of supra-
temporal verities, he underwent an inner renewal and release,
an inappreciable widening of horizon. On the other hand, he
acquired a deepened knowledge of technical resources and rules
of his art, and an incomparable mastery in the craft of the
painter, in the art of fresco in particular. It is with this firmness
and certitude in the possession of the means that the virtue of
art arrives, if it may be so put, at the adult state in a spirit.

The book *Du Cubisme au Classicisme*,[1] doubtlessly bears the
trace of an exaggerated confidence in calculation and rational
combination, in a logical rigor of conception and of execution
that remains still in the material order. It survives as a significant
witness. Severini can find nowadays that, drawn by theory too
far from his own nature, he gave then too much importance to
a side of art which, in reality, at the bottom of his mind, he had
always judged secondary. Nevertheless, this very excess of re-
flection was like a sign that his art passed at that point through
the crisis of the ungrateful age—from the life of the senses to
that of reason. The painter, at the same time, by his solicitude
for the workman's perfection, by his passionate attachment to
all the concrete detail of honest work, straightforward and

[1] Paris, Polovosky, 1921.

rigorous, escaped the perils of menacing abstraction, and entered in spite of everything more deeply into his true nature, which relates him so closely to the seekers of the early Italian Renaissance.

But this classicism also had to be evaded. Then there took place a new progress, more difficult (because the denudation was now to act upon a richer and more organized substance) and in which Severini was to be aided by the effort for objectivity, the kind of constant sacrifice exacted by great mural decorations with religious subjects. Called to decorate a church in French-speaking Switzerland, he spent there more than two years, having himself the sole charge of all the ornamentation,[1] and conducting an immense labor with furious energy, under very hard physical conditions. He accomplished his purpose admirably. By the authority alone of composition, and with an eloquence purely pictorial, free of all expressionism of anecdote or of psychology, the great frescoes of the choir reunite us to the high tradition of sacred art. As for the decoration, that spreads over the whole space perfectly assembled and accorded, a winged people of variegated numbers, the inventive genius of Severini here is deployed with unfailing freedom. One sees affirmed here the evidence of certain possibilities, often disregarded, which are offered by the art of our time.

In the frescoes of the Church of La Roche, in the *Last Supper* in particular, religious sentiment more freely expressed, an ac-

[1] Except the chapel with the baptismal fonts, all the church of Semsales is painted by Severini. Since then, Severini has decorated other churches at La Roche, at Fribourg, at Geneva.

crued emotion is permitted by the pictorial rigor to appear.
Alexandre Cingria is right to affirm that Severini should be hailed
"as one of the powerful actors of the renaissance of religious
art."

I have often repeated that art is brought remarkably close
to religious use by the most daring modern researches, requir-
ing as they do much formal purification. It is not the newness
of their means, but rather the spirit from which they seek in-
spiration that often keeps them apart from such usage.

It would need an essential purification, an interior renovation
of this spirit—which does not happen without a sort of agony,
and which the majority refuses. Semsales and La Roche show
us the victory of a painter who has lived out the modern anxieties
and discoveries, and has never renounced them and who has
been rendered master of his soul at the same time by a great
inner deepening.

Severini has nothing henceforth to do but to confirm this
victory. After a short stop in Rome, he is again in Paris[1] and
what he has sent to recent exhibitions (certain still-lifes in par-
ticular which are like fruits ripened under the implacably pure
sky of a world where everything is true) has revealed this sleek
vivacious force, proper to him who does what he wants to do.
He seems to have decided to quit for a certain time fresco and
mural decoration, and to express himself in a fashion which
lends itself better to the good pleasure of inspiration. He is
free enough now to make the synthesis of himself. After a phase

[1] And now (1935), again in Rome.

of instinctive pouring forth, and a phase of rational rigorism, his art, having undergone the normal flux and reflux of vital renewals, can again give place to the spontaneity of sense henceforth dominated by the spirit. By dint of fidelity, this art succeeds in resolving the inevitable conflict of spontaneity and self-awareness, and to affirm itself as a spiritual instinct imbued with reason, like a calculating spontaneity. Severini's life, like that of every great artist, but with a particularly striking sharpness and clearness, shows us a constant ascension, oriented toward the unification of diversities and oppositions in appearance irreducible. A tenacious research for authenticity and the just measure, for a perfect probity and transparency in the order of working as well as moral reason have permitted Severini to reconcile and to fortify one by the other the rectitude of art and that of life, and at the same stroke modern aspirations and the pictorial tradition of the great artisans with the naïve hearts: purity, childlikeness, reason, fantasy, clarity of spirit, popular vigor, sureness of the creative *virtù*.

Remote from neo-classicism, he is with simplicity a man of our times; he is also the brother of the painters who lived in that incomparable epoch—six and seven hundred years ago—when science and reflection, before letting themselves be led by the fanfares of pride, united already self-conscious certitudes with a limpidity of soul as yet unaltered.

(1930)

DIALOGUES

*To Nicolas Nabokoff
and Roland-Manuel*

DIALOGUES

A literary period betrays itself by the lexicon of its admirations. Most of the time the lexicon signifies less what the period attains than what it lacks; what it succeeds above all in counterfeiting and in spoiling.

Today, in literature, all is for spirit, for purity.

*

"I beheld Satan as lightning fall from heaven."[1] The spectacle continues. In the past century two great disasters threw their fire into the night. Nietzsche fallen from the heaven of liberty, Wilde from the heaven of art.

A long and slow bookish work of the school and the university, the romantic German metaphysics and a certain Greek English purism emptying into the heart and flesh of man. Schopenhauer and Walter Pater[2] are hidden in the shadow of the drama.

*

Beauty has not come to the end of its submission to the shameful ascendancy of the god Aesthetics taken as the ultimate end of human life. The interminable, incoercible, appalling laugh of Oscar Wilde consigning a man to sin,[3] still passes like a voluble cry over our arts. It is this that freezes them in their frenzy.

[1] Luke, X, 18.
[2] The Walter Pater of *The Renaissance* (of which he withdrew, however, the *conclusion* when he saw what consequences Wilde drew from it).
[3] Cf. André Gide, *Si le grain ne meurt.*

41

*

The Angels, perfect natures, cannot turn aside naturally from nature; it is at the supernatural stage that their evil begins; the devil has a supernatural hatred of nature. He uses art to teach it to us.

*

Contraries cannot unite themselves in the truth; but in error? The modern spirit is at once Rousseauist and Manichean. The adoration of nature and the hatred of nature together outrage the Gospel. The dogma of grace reconciles at the height of the Cross what in the regions of dissemblance is only contradiction tearing the heart.

*

To put in his life, not in his work, his genius as an artist, nothing more absurd than this design of Wilde; it is to carry over into a flute the art of the cithera, into a bird the law of the snow. His life was only a useless phrase.

It was not the hard labor that broke him. Frank Harris remarks that he came out of prison in a better state than when he entered it. His art itself profited by the prison diet; as witness *De Profundis* and the *Ballad of Reading Gaol.* It was Lord Douglas who broke him. Sin kills poetry also.

In Paris, the priest arrived in time to save his soul, too late to save his art. Art is confined in the terrestrial duration; for it no mercy *in extremis.*

*

The poets complain of moralists. They themselves constantly

confound art and morality to the detriment of both. A confusion
of aesthetic values and ethical values, one of the scourges of our
time.

<p style="text-align:center">*</p>

PURITY. Of this word itself an impure use has been made.
It has become an equivocal word, dragged about everywhere. At
the Marquis of Sade's, at the Tcheka, etc.

A human act that no moral value affects, that the distinction
between good and evil does not even graze, that which no meas-
ure, human or divine, can come to touch, except the numbers of
sensation, that is "pure". A crime, a vice, a lie, a soiling, malice,
blasphemy, all this is "pure" if it is intact, if it is well made, if
no turn of reason judges it and interrupts its movement. Always
Jean-Jacques Rousseau: the man who meditates is a depraved
animal. Hence the culmination of impurity is decency. A *sincere*
priest would mount naked to the altar, as in the black mass.

To clothe in one's self animality with humanity, the senses
with reason and wisdom, and humanity itself with the merits of
Christ and of his charity, to cover one's hands with the grace of
God in order to touch God, as Jacob approaching Isaac with the
hands of Esau, this is duplicity, hypocrisy. Sincerity exacts that
you should be only what you are in the lowest depth of your
being; and purity requires you to show it.

The surrealists dialogue on love.

<p style="text-align:center">*</p>

I know that it is by the example of a lie that the history of
Jacob and Rebecca instructs us. The vocabulary of images that

God makes for us uses everything to suggest divine things. But of what verity this lie is the figure! To get to the bottom of sincerity, to avow truly what we are and at the same time what God is, it is needful to disguise us—without falsehood this time, and thanks to a gift that transfigures being—in Another Who is more we than we ourselves, and Who vivifies us with a life better than ours. And His blood colors my cheeks, said St. Agnes.

*

The plants, said Aristotle, live in a perpetual sleep; because they have only a vegetative soul, all their aim is in the flower. They have their mouth in the earth, and it is their hermaphroditic corolla that they expose to the birds of heaven, without the least repression.

Literature, today, would be that plant.

*

One imagines that in paradise innocence was to ignore good and evil. Purity consists then in behaving as if evil did not exist. I say that is a lie:—the purity of the human being is to recognize the law not of the plant, but of man. In paradise all was not permitted; innocence was not to do good or evil without constraint, but to do only good without suffering conflict. The desire for the knowledge of good and evil was the desire to become, like a god, the rule for good and evil, and also to scrutinize what the taste of evil contains of knowledge.

Since that time there is no purity save under another tree, where God extended his arms to die.

*

Poetic purity is a mineral purity. Purity is a human virtue.

*

Art is not a caricature of creation, it *continues* creation, "creates as it were in the second stage."[1] Morality is not a code of respectability, it is the code of the tests of love.

Because art (that which is true) reflects morality, to declare that art exacts a life morally dangerous, and new experiments in morality as in aesthetics (that is to say experiments to render innocent, thanks to the sorcery of the heart, the very things that God forbids) that means, if you like, subordinating art to morality, but to a morality that art has violated. Under the pretext of taking in art the place of aesthetics, it becomes itself the prey and victim of art.

*

"One does not stop a bird from singing." But if thy right eye offend thee, pluck it out, said the Saviour.

An author is not a bird. And a bird's song is never anything but the song of the eternal law, in an obedient creature.

*

To live dangerously. The only way that is free of bravado and deception is to live as a Christian; to steal nothing from love and yet to subtract nothing from the law.

It is easy to practice the law without loving, and easy to love while scorning the law. But he who practices the law without loving does not practice the law, because the first commandment

[1] *Art and Scholasticism*, London, 1930-1934, p. 63.

is love. And he who loves while scorning the law does not love, because the law is the first will of Him Who loves us, and Whom we love. The Christian gives up his life every day, he embraces both the law and love; which, joined together, form the cross.

*

HARDNESS. Nothing is softer than a gratuitous act, that cheap outburst of irresponsibility preached by the disciples of André Gide. It is the ultimate form of obsequiousness, a cringing before nothingness.

"Love is as hard as hell." Make your choice. You will find only in one or the other an authentic hardness.

*

Hardness, ellipsis, horror of sentimentalism and of transition, of convention, of roundness, of abundance, these the young men have immediately understood and utilized: there are as many recipes for style, better doubtless, and as easy, alas, as some others. But when these pass into their heart, lead them to hate pity, to cherish envy, malice, villainy, to insult their mothers ritually, to link themselves by pacts of sorcery, they are once more and without even knowing it, the victims of aestheticism. The last Dandies.

*

SPIRIT. It is in the flesh itself that modern heresy seeks the spirit. It plants therein all the sins of the spirit, pride, the disdain of God. What it fears above all is truth.

To love only to seek—on condition of never finding—to want only disquietude, that is to hate truth.

*

The sins against the Spirit are those which destroy in man just that which places him at the disposal of mercy: repentance, hope, consent to the truth. . . . If many of those who have nothing but the spirit in their speech appear to apply themselves to these sins, it is that another Spirit exerts himself to make them imitate his obstinacy.

A good part of current literature is positively possessed. In it could be verified some of the signs used by priests to detect possession: the horror of holy things, pseudo-prophecy, the use of unknown tongues, even levitation; it may be seen circulating upside down, along the vaults of thought.

*

"Psychic" or natural man receives through the senses all that comes to him from without; it is through them that his ideas come to him, by means of the activity of the intellect. Reason, which transcends the senses, labors however in their work-yard. Philosophy, even the best, remains tributary to their materials.

That is why mystical language knows only two terms: life according to the senses and life according to the spirit; those who sleep in their senses and those who wake in the Holy Spirit. Because there are for us only two fountain-heads: the senses and the Spirit of God.

Man has a spiritual soul, but which informs a body. If it be a question of passing to a life wholly spiritual, his reason does not suffice; his tentatives toward angelism always fail. His only

authentic spirituality[1] is bound to grace and to the Holy Spirit.

"The 'psychic' or natural man receiveth not the things of the Spirit of God; for they are foolishness unto him: neither can he know them, because they are spiritually discerned. But he that is spiritual judgeth all things, yet he himself is judged of no man. For who hath known the mind of the Lord, that he may instruct Him? But we have the mind of Christ."[2] Saint Paul judges all the philosophers. He is not judged by them.

*

GREATNESS. Another hackneyed notion of the time. If the time finds nothing, it is not for want of knowing what must be sought.

Greatness is impossible where God, humility, intelligence, love, personality are lacking. On the other hand people know enough not to expect greatness of the mere display of quantity, of Wagnerism.

There remain mechanics and the shock that shakes the body for a moment.

[1] The context shows well enough that I am speaking here of spirituality in the absolute, or pure and simple, sense—of the one that takes possession of the being in its entirety. Moreover I have explained this in *The Degrees of Knowledge*, (p. 328 et seq.). "But the mark of spirituality may be imprinted only on some part or aspect of our being or our life: then it is spirituality *of a kind*, or viewed from a certain side. In this sense there exists a natural spirituality of multiple degrees and of various forms, by which the human soul bears witness to its proper essence," and to the natural love of God inscribed in the depth of our being. If M. Maurice Blondel had paid attention to these pages, he would have spared himself a misunderstanding on the sense of a "sally" as he calls it, that scandalized him in the first chapter of this same work, *The Degrees of Knowledge*, and to which he devotes in *La Pensée* some austere reflections. There is many a scandal in the world, this one was superfluous. (1935.)

[2] Saint Paul, I Cor., II, 14—16.

*

HEART. I do not consent to seeing here a fetish charged with remaking the world better than God had made it.

*

In certain philosophers the heart has climbed into the head, to mask an absence.

Hence a curious psychological disorder. When the heart is in the head, thought suffers doubtlessly, but sentiment does also. No one has more bitter affections than the theorists of the charity-philosophy.

*

L'amore che non è amato. What is love if it does not love Love? The heart if it is not occupied by God? Saint Francis condemns the profanation of the heart.

*

To choose the heart for emblem is to dedicate one's self to the only Heart which does not lie, and it is encircled with thorns.

*

In its agony on Gethsemane it agonizes until the end of time, because all of the past and all of the future was rolled up within it on that night. Open on the cross, it bleeds in the Church, because the Church continues in her members the passion of her Head.

Therefore we should through all the length of time console this Heart inhabited by beatitude; here today, in the encyclical *Miserentissimus,* the Pope entreats men to console God. After

having explained these things, he adds, quoting Saint Augustine: "Give me one who loves, and he will understand what I say."

<div align="center">✴</div>

SINCERITY. There is a *speculative* sincerity, I mean with respect to the self and in the very order of the interior life; a straightforward gaze before which the heart spreads like a deployed campaign; for which the shames, the opprobriums, the social prohibitions and all the rules concerning the dialogue with others, do not enter in, transferred to the secret colloquy in which God alone takes part, to dissimulate aught of what is. If such a sincerity is not frequent, this is because it requires courage.

The saints possess it, lighted as they are by the gift of knowledge, illumination of tears, and upheld by the gift of strength, which prevents them from dying of grief in seeing themselves. On another level certain gifts of the artistic order procure this kind of sincerity in their manner. Such appeared in profane literature, at the price of what ransom, of what redoubtable availability, the privilege of Proust. Such is also, in the mystical description of the most singular religious itinerary, the marvellous gift that we find in René Schwob.[1]

<div align="center">✳</div>

The mortal error of many minds capable if not of having, at least of estimating this *speculative* sincerity is to counterfeit it in the order of action, where a false *practical* sincerity soon becomes the unique virtue.

[1] I was thinking of *Moi Juif* in writing these lines; *Ni Grec ni Juif*, published afterward, demonstrates the same admirable gift.

This "virtue" will be then not to see the self but to accept it at each moment just as one finds it, without choosing or preferring or *forming* anything in the self. This is a sincerity of matter, of the formless as such and of dispersion. As if it were a lie to touch our internal possibilities in order to conform them to our deepest law and to our eternal example! El Greco then who paints the Burial of Count Orgaz is lying; his colors on his palette—there is his sincerity.

*

All sin is a sorry thing, injuring nature. There is no pure sin. The pure contour of impurity is an impure thing.

I did not make myself, nor save myself; my sin injures the work of another, and disfigures the visage of another.

In making out of your sin beauty, you send it like an angel among your brothers. It kills them without a sound. However, this is not your first fault. But that of yourself within yourself for having hidden a corpse in the branches of your arteries, as if God did not see.

*

It is a trait of pedantry to hold that all virtue is hypocrisy, all personality theatre mask. The *form of reason* is naturally postulated by what we are. The *form of grace* (without which reason forms us crookedly) is, while freely bestowed,—being supernatural and descending from the Principle—dearer to nature than nature herself.

*

The theologian considers personality in the world of the

deity, the metaphysician in the world of being insofar as it is being, the psychologist in the world of inner phenomena, the moralist in the world of action. Most often these considerations remain disjointed, which engenders in the mind a species of pluralism of the worst kind.

It then happens, when levels are muddled by chance, that the *person* of the metaphysician finds himself astray in the dictionary of the psychologist. The latter, satisfying himself and with reason that the metaphysical person is neither this phenomenon nor that one, takes it for an "illusion of common-sense". One barleycorn would be more to his liking.

<p style="text-align:center">*</p>

All the formless flowing phantoms and all the duplicities which put several men in a man, and contrary simultaneous postulations (without going so far as to dislocate the substratum of free will between two opposed final ends and efficaciously loved above all), are compatible with the substantial unity of the metaphysical personality. But this last, which is the subsistence itself of the spiritual soul, does not realize itself in action, does not become a moral personality except by the formative sap of intelligence and love and of their virtues.

Still another sap, and a better, rises in us. Because of it, and of the Vine of which we are the branches, the vine-grower prunes us so that we may bear fruit.

<p style="text-align:center">*</p>

Gide and Dostoievsky. Gide sympathizes so much with his model that he confuses its semblance with his own. He is aware

of this, withal, and judges doubtless that no veritable artist could paint otherwise; which is at once true and false, like many literary theses.

Dostoievsky never sent his younger brother to seek freedom in sin more daringly than he had done himself. He loved this brother too much, he had made his own voyage with too much sagacity, he knew too well what sin is.

*

A linguistic detail, contributed by Mrs. Hoffmann and carefully noted by Gide:[1] "There exists in Russian only one word to designate the unfortunate man and the criminal."

I open Makaroff's dictionary; I see that "unfortunate" is in Russian *niestchastni,* and "criminal"—*prestoupnik.*

To commit a crime knowing it a crime, and to sink further into it out of despair, certainly that is Russian (and human). But it is something wholly other than confounding crime and misfortune.

*

Dostoievsky met Christ at hard labor, and did not turn away. *Time Jesum transeuntem et non amplius revertentem.*[2]

One day Dostoievsky had his eyes opened on the spiritual world by a touch of the Gospel and he remained forever troubled by it, because the intuitions of his heart did not find on the side of his intelligence the pure certitudes that should have stabilized

[1] André Gide, *Dostoievsky*, Paris, Plon, 1923, p. 121.
[2] "Fear Jesus Who passes and does not return."

them.[1] Misguided by his time (and by Jean-Jacques Rousseau), he never believed that reason can justify that distinction between good and evil to which he submitted his thought. He does not seem, either, to have become aware of the essentially super-natural certitude of that faith in the Redeemer to which his soul was appendant.

His misfortune is to have created a sort of schism between love and wisdom, not to have understood that the former is exhaled by the latter. He himself was the first victim of his misunderstanding of Catholicism.

<div align="center">*</div>

Gide has very rightly noted, "nothing is less gratuitous—in the sense given nowadays to the word—than the work of Dos-toievsky. Each of his novels is a sort of demonstration; one could almost say a special pleading—or better still a sermon." He wrote *The Brothers Karamazov* and *The Demons* to project on atheism the terrible light that was consuming him.

Shall I add that his example suffices perhaps to show that it is possible to "know that what you write will have an effect" without curbing on that account your art and thought? Dos-toievsky "retains, in face of human reality, a humble, submissive attitude; he never forces, he never diverts the event toward him-self." Well and good. This is to say that his art does not give way, while he uses it for his God.

<div align="center">*</div>

"Dostoievsky is not properly speaking a thinker, he is a

[1] Hence also the disquietude of his political thought oscillating from a singular Utopian theocratism to an impotent resignation in autocracy; a weakness that Soviet criticism in Russia has only too well uncovered today.

novelist." André Gide explains to us very well that clumsy as he is in expressing his thoughts on his own account and on the abstract plane, Dostoievsky mingles them with the flesh and blood of his characters and makes them live in them; they are not the ideas of a philosopher, contemplative ideas, they are the ideas of an artist, factive ideas. Nothing could be more exact—provided it is added that this novelist is a theologian-novelist, a prophet-novelist. But then, let us beware, in trying to disentangle his thoughts, of misjudging the admirable complexity of the creative synthesis, of attributing to the artist in too brutal a manner, as issuing directly *from him,* what is not his except through and in the matter that he animates, what does not manifest his thought save by the rays a thousand times refracted, and by the total distribution of the light, and by the portions of shadow as much as by the light.

Let us beware also of attributing to the painter what belongs to the model. The *objective* character of Dostoiesky's work, it seems to me, has not been sufficiently stressed. He wanted to paint his brothers, and lay bare their wounds. Potentially he had all these wounds within him, I know (and has not each of us within him all the wounds of the human race?). Thus he has been able to describe them with a surer exactitude, he did not call them *health,* nor love them for that. From a certain point of view, this mystic of the Russian nation, who hated in Turgenieff the uprooted Russian, appears himself as an Occidental writer, so lucid and *separate* is the gaze he brings to bear upon the soul of his own folk.

*

"If God exists, all depends on Him, and I can do nothing outside of His will. If He does not exist, all depends on me, and I am bound to affirm my independence . . .

"I have sought for three years the attribute of my divinity, and I have found it; the attribute of my divinity is independence. It is anything by which I can show in the highest degree my insubordination, my new and terrible liberty, for it is terrible. I will kill myself to affirm my insubordination, my new and terrible liberty . . ."

It is the whole drama of the modern world that Dostoievsky gathers into Kirilov's poor room: the history of the conquest of *aseitas,* Existence through Self. A created God does not create, at least he can destroy. Kirilov reasons well, he sees clearly.

But he starts from the mad principle *against which* Dostoiesky took his stand, which he held to be the great homicidal Error. However little one makes of the theoretic writings where Dostoiesky affirms his thought directly, it would be strange all the same to take no account of them, and to neglect the testimony of the *Journal of a Writer.*

Why then, after a series of imperceptible warpings, after having insinuated that the dialogue between Peter Stepanovitch and Kirilov "remained very mysterious even in the thought of Dostoievsky" (why this? Dostoievsky does not appear to dominate his subject anywhere else with a more lucid consciousness) and that Kirilov has ideas "all of which Dostoievsky does not approve of" (I can well believe it, these are his enemies)—

why tell us at the end that "if the words of Kirilov appear to us somewhat incoherent at first sight, nevertheless through them it is truly *Dostoievsky's own thought* that we end up by discovering"?[1] Well, no! Not even an obscure recess of that thought.

*

"I well know," Gide told us thirty years ago,[2] "that Dostoievsky put these words in the mouth of a madman; but perhaps a certain madness is *necessary* to get certain things said for the first time;—perhaps this was felt by Nietzsche. What matters is that the things be said; for now it is no longer needful to be mad to think them."

Alas no; it is enough to be an "up-to-date" person. Angèle, fond in everything of pretexts, can think these things without danger. But in the heart of Nietzsche and of Kirilov things take on all their dimensions. Their madness passes judgment on their ideas—not because it is at the origin of these ideas but because it is their consequence. And perhaps, indeed, for the laws of reversibility are unfathomable, this madness is for our healing —not in order that we be so inconsistent as to think mad things without being mad, but that we have the simplicity of not wanting to think mad things.

God grant that no Christian prostrate himself before sin, as, at least according to Gide, Father Zossima prostrated himself before Dmitri Karamazov. But he would, rather, bend his knee before the fate of a Kirilov or of a Nietzsche, adoring in it the eternal

[1] André Gide, *Dostoievsky*, p. 282. Our italics.
[2] A Angèle, December 10, 1898 (*Prétextes*).

decrees, and a mercy above our thoughts.

*

André Gide sees happening in the history of Kirilov I know not what shadow of redemptive sacrifice, he finds in Dostoievsky's *Correspondence* a high doctrine of voluntary sacrifice, that throws, he says, a strange light on the character of Kirilov. Does he forget here that the artist uses the best that is in him to make his monsters, and that Dostoievsky had need exactly of that high idea of sacrifice to compose the character in whom there should appear, in a distorted image of sacrifice, the remaining vestige of its greatness?

The ancients taught that, as vitiation of being or more exactly privation, *privatio boni debiti,* evil "always has good for its bearer". Dostoievsky was not ignorant of this law of creation. He knew that evil only subsists and acts through good, and that in all error there glitters a broken reflection of the truth. It is because of this that Kirilov is a living being and that there is in him a human substance to love and save.

*

Every novel is a mirror borne along before the *futuribilia*[1] and before the laws of divine government, and the novelist who does not believe in moral values destroys in himself the very matter of his art.

In behalf of that one of his characters who most resembles

[1] The theologians call *futuribilia* the events which *would have come to pass,* according to divine foreknowledge, if something which did not take place had taken place at a given moment.

his own confession, Stravoguin of *The Demons*, Dostoievsky contrives no alibi, he leads him to his miserable suicide with a severity, a clairvoyance, a logic without pity. He loves him however, for it is himself, or at least the dark face of himself. But it is exactly here that best appears, in my sense, the transcendence of his genius as a novelist. His work is similar to the living universe, there is in it a sort of *metaphysical pathos* because the beings who move about in it are, to a certain degree, in the same relation to the thought that creates them, as men are to God. He loves his characters, more tenderly perhaps than does any other artist, he puts himself into them more than does any other; at the same time, he scrutinizes them and judges them inflexibly.

*

This great idea of the novel I like to find again in a Julian Green. So much does he respect in his art the creative miracle and the invisible roots that join it to the kingdom of the heavens, that an accepted complacence to what injures the soul would seem to him to put to death his gifts.

How avoid noting here the importance of a work like *Les Clefs de la Mort?* Here the intangible is touched; here may be felt that admirable tremor produced by a profound respect for the subject in a fervent hand.

*

"The essential question is not to know if a novelist can or cannot paint a particular aspect of evil. The essential question is to know *at what height* he places himself to make this paint-

ing, and if his heart and his art are pure enough, and strong enough, to make it without connivance."[1]

Is this to say that according to me the novelist should isolate himself from his characters, to observe them from outside, as a scientist follows in his laboratory the experiments that he has instituted? Really now; would the character exist if he did not live in his author, and his author in him? It is not by virtue of a simple metaphor, but indeed of a profound analogy, that it behooves us to place the art of the novel in the theological light of the mystery of creation properly so-called. "Contrary to other literary forms the novel has for its object, not a thing to be fabricated having in the world of *artefacta* its proper beauty and of which human life furnishes only the elements, but its object is human life itself to be conducted in a fiction, as the Art of Providence does in reality. Its object of creation is humanity itself to be formed, scrutinized and governed like a world."[2] An imaginary humanity is meant, that takes birth in the heart of man and reveals man to himself. In this sense, one can say with Mauriac that the knowledge of man is the proper goal for the literature of the novel.

<div align="center">*</div>

Immanence and transcendence—is there anything more intimate to creatures than their Creator? It is in Himself that He knows them, they are the freely willed participations of His essence. And Himself in Himself is perfectly separate from them.

[1] *Art and Scholasticism*, London, 1930-1934, p. 224, (Note 154).
[2] *Ibid.*

Man is too poor a creature, even with respect to his images, to be capable of such a delicate distinction. Sometimes he cuts himself off too much from what he is creating, sometimes he mingles himself in it. It remains that the boundary to which to tend is very clearly determined.

Let us not confound the union of love and the union of complicity. *Amor extasim faciens*: It is by love, not by an obscure collusion, that the novelist is in his characters. He does not paint them well, he does not know them unless, living in them, he judges them. Not to "intervene" from without and twist their destiny. But, on the contrary, to follow their destiny from within, and make it true.

<p style="text-align:center">*</p>

Mauriac cites a page where I have written: "There is a secret of the heart that is closed to the angels, open only to the sacerdotal knowledge of Christ. A Freud today, by the tricks of the psychologist, undertakes to violate it. Christ looked into the eyes of the adulterous woman, and saw all, to the depths; He alone could do this unsullied. Every novelist reads without shame in those poor eyes and brings his readers to the show."[1]

I seek in vain in these lines the slightest wish for "an oratorical combative literature in which the characters, representatives of a race, samples of a class or a generation, would be mobilized in favor of a particular ideology."[2] I hold such a

[1] *Trois Réformateurs*, p. 170 (*Three Reformers*, p. 119).
[2] Francois Mauriac, *Le Roman*, Paris, 1928, p. 40.

literature—ideological drama or novel—as the least defensible literature.

"We dare to read in the poorest eyes, because nothing of what is human makes us indignant or disgusted."[1]

Indignation? disgust? No, verily, it is respect that I am asking for those poor eyes. In the sin itself of the creature abides a mystery that is sacred to us; this wound at least belongs to him, it is his miserable good for which he engages his eternal life, and in the folds of which are hidden God's justice and compassion. To heal this wound Christ willed to die. To see as far as He into the sinful soul, it would be necessary to love it with as much tenderness and purity.

<p style="text-align:center">*</p>

And so, I do not adjure the novelist to turn his regard away from those eyes. I simply *note the fact* that he does look into them and proposes reading to their depth.

And I think, also, that a fundamental exigency of his art impels him thus to scrutinize the recesses of the most individual sensibility, until he catches a glimpse of the monster of singularity (I say singularity, not anomaly) that lies in each of us.

But I ask that at least the significance of such a fact be understood. I ask that we see to what it pledges us, under penalty of falsifying and disfiguring everything.

<p style="text-align:center">*</p>

It is in no wise enough not to separate daring from decency —which is, as Mauriac very rightly notes, a question of style.

[1] *Ibid*, p. 41.

No more does it suffice to recognize that "the gift of self, the taste for purity and for perfection, the hunger and thirst after justice, this too is the human patrimony; to this too, we novelists, should bear witness"; by reason of which "the work of the Christian Dostoievsky rises so far above that of Proust."[1]

This is truth itself, but it is not enough. Because the question is to discover the whole of man, and because in good and evil, in the use of grace and its refusal, there is in man much more than man: it is not only the lucidity of a Meredith, it is the apperception of a Pascal that the novelist, insofar as he is a novelist, should envy. It is by virtue of an intrinsic law of his art that it must be said: "The more deeply the modern novel probes human misery, the more does it require superhuman virtues in the novelist. To write Proust's work as it asked to be written would have required the inner light of a Saint Augustine."[2]

Lacking that light, one must know how to limit one's self.

After all, it would be the proof of an extreme mental exhaustion to suppose that there are no other possible themes for the novelist than those of Proust or of Colette.

From this point of view, *Sous le soleil de Satan*[3] marked the end of a bewitchment.

*

The role of the novelist is not that of the scientist. The scientist propagates only notions, concerns himself with truth

[1] Francois Mauriac, *Le Roman,* p. 69.
[2] *Art and Scholasticism*, p. 225, Note 154.
[3] The first book published by Georges Bernanos.

alone. He addresses only a limited public of specialized readers.

The novelist is answerable for a practically illimitable influence. His readers are only rarely those for whom his message is designed (and they are few in number). He knows it. He complains of it. He profits by it. He holds to it.

This *boundlessness* of the public renders the problem more and more difficult. Is the novelist sometimes perplexed about the consequences of his work (for they are often ambiguous), there remains for him, in any case, a sure criterion: if he is careful to paint, according to the rule we were discussing above, only that which he can paint without connivance with evil, this severity toward himself will be, without exempting him from the solicitude for others, the essential standard for what is permitted to his work.

*

In default of the light of the gift of knowledge, the novelist has at hand other recourses.

The dangerous consciousness of itself gained by the modern novel obliges it more and more to choose *between spirits*.

*

"One would have to be a saint. . . . But then one would not write novels."[1]

There, in two lines, is the whole debate of Mauriac. But of course one would. One would write novels if one were born a novelist.

[1] François Mauriac, *Le Roman*, p. 80.

*

One is *a saint* only after death. Before, one is on the way.

Let us therefore say: "One would have to *tend* toward saint-hood, toward the perfection of charity." But this is precept. Let us then say: "One would have to be a Christian."

*

Sainthood is not the negation of human life. Saints have been kings, artisans, preachers, doctors, priests, painters, poets. Why should they not be novelists?

I fear that there is in Mauriac a kind of Manicheism, the primary cause of his torments. He is very near imagining, as Gide does, that the devil collaborates in every work of art, and that of itself the novel is a complicity with evil. In the same way, under the pretext that each individual bears within him the four wounds of original sin, he goes on to an altogether different conclusion: to postulate in everyone, even the most purified, a certain privilege of evil, a reserved right of sin, a secret but actual taint, a hidden perversity.[1] An abyss of solitude —granted! The individual may be thus defined. But by the spirit souls communicate. And there are abysses inhabited by grace, where it puts light and order; there are abysses of charity.

[1] Since these lines were written, many things have changed for Mauriac. *Souffrances et Bonheur du chrétien* marks this turning. "The whole question comes back for me, henceforth, to this: *to purify the source*," writes Mauriac in *Dieu et Mammon.* May he be thanked for the words that he adds on the sub-ject of the present essay. The observations I have made here lose their relevance with respect to books like *Le Noeud de Vipères* and *La Fin de la Nuit,* novels the more truly Christian in that they are so through and through.

On *François Mauriac et le Problème du Romancier catholique,* Charles Du Bos has written some penetrating pages (Paris, Correa), which will be com-plemented, we hope, by a long-promised study on Gertrud von Le Fort. (1935.)

No doubt all the monsters exist there potentially, sometimes poisoned shadows rise up from the depths as if trying to take on body, without being, however, consented to; love only loves the more, it knows that to be enough.

The redemptive blood, which can make a man into a friend of God, is able indeed to exorcise art and the novel, if it touches them. "Let it be received, the precious blood, and all will be reborn."[1]

This condition, it is true, is indispensable: wherever there is not the grace of Christ, the prince of this world occupies the place. And art is the flower and perfection of this world.

<p style="text-align:center">*</p>

"Nothing wears out God in a soul more surely than to have made use of Him, in periods of troubled years. The least dangerous manner of being moved, that is without doubt what my twentieth year was seeking in religion . . ."[2]

Jansenism is only the counterpart of such an error. It is not by such a doctrine that this mistake may be cured.

"Woe to the boy for whom the nails, the sponge of gall, the crown of thorns were the first *toys*." Mauriac has too much sagacity not to understand what such a cruel confidence means for himself. It seems that he is entering into a night of which the very danger is too pressing not to oblige him to an heroic

[1] Raïssa Maritain, *Le Prince de ce Monde*, Paris, Desclée De Brouwer. *The Prince of This World*, done into English by Gerald B. Phelan, St. Dominic's Press, Ditchling, Hassocks, Sussex.

[2] François Mauriac, Avant-Propos à la nouvelle édition des *Mains Jointes*. Paris, Paul Hartmann, 1927.

hope. In one manner or another, the instruction given to all of us has miscarried, and we have played with what was not to be played with nor laughed at. The piety of childhood cannot last if man does not nourish it with knowledge and with prayer. It is our good fortune, then, to go through the experience of the void that announces, if only the desire is present, a graver and deeper knowledge of the things of God.

(1928.)

THE FREEDOM OF SONG

To Gouverneur Paulding

THE FREEDOM OF SONG
I

Art and Scholasticism appeared in 1920. Rereading in 1935 the proofs of the third edition, it seemed to me that the ideas proposed in this book can pass without too much detriment through the vicissitudes of the art seasons. They are analogical principles.

As for the present situation in the art of the moment, it has entirely changed in fifteen years. What is more out of style than Cubism? Pictorial and poetic angelism appears to be quite done for. An art that refused to contemplate, an intelligence that wished to be without a single moment of passivity, a fabricator only of worlds and forms, by dint of activity they confess their own void—the natural void of the human intellect when un-invaded by the *other*. By dint of elevating themselves through the sole virtue of thinness and agility into forbidden heights, they finally perceive that they have no more weight. Like Chamisso's hero, this art had lost its shadow.

One thinks with melancholy that all that it nevertheless dis-covered in certain rare domains of creative guile and of the exigencies of the worker's purity—and, alas and alack, in the domain of refined taste too—that all this lesson seems entirely lost for the hasty fellows who have come since. It will be of service later, perhaps.

The most significant event, from the point of view that con-cerns us, is the tragedy of Picasso. This great painter, enraged

71

over his inability to transubstantiate things and to create out of
nothing, is revenging himself on painting, and at the moment
of entering into the liberty of perfect age, finds open before him
only the irrespirable spaces where a great ravaged poetry throws
its admirable plaints. An ungrateful people then discover that
he has made art out of art, and no longer see the courage or
the beauty of his heroic adventure.

The case of Stravinsky is different. He advances through the
same zone of peril, but he overcomes it as a result of his assiduity
in the sacred egoism of the creative spirit, and because he is
obstinately bent on obeying jealously the figures and the operative
rules of the nature-like producing will. He fears the eternal laws,
this ferocious intellect in love with the song of the daughters of
men; because of this his birth-givings of a demi-god—*isti sunt
potentes a saeculo viri famosi*[1]—can beel themselves well-assured
and firmly entrenched in their own power, if only they can escape
sheer craft and athleticism.

The "conversion," or let us say the adherence, since the first
word displeases him, of André Gide to communism, must be
remembered as another typical event. Those who have accused
him for so long of refusing himself all option in order to stick
only to his taste for useless liberty and for the pleasure of
unfetteredness should be the last ones to reproach him with this
option. What is painful is to think that this soul, who has loved
the Gospel, and who still loves it, should have put a last hope,
not altogether exempt after all from the fear of being disap-

[1] Gen., VI, 4.

pointed,[1] only in the experience of an integral atheism—out of which his curiosity, cruel to himself and to others, is doubtless looking for who knows what revelation. This then is what he awaited in order to confess at last his need to serve and to give his devotion. Where indeed does man not go to search for a precarious equivalent to sacrifice? In an artist of the quality of Gide, consenting to enroll himself in the least free of parties, where—whatever he thinks—he undergoes the contact and the solidarity with the blasphemies of the anti-God propaganda[2] which he scorns—it is not an indifferent spectacle to see bewildered pity triumph over the apprehensions of the intelligence and the heart; the very ignorance of social problems in which this new disciple of Marx has remained all his life makes one appreciate in his decision the courage of having braved his own weakness.

The naïve injustice with which he imputes to the faith the defects of the faithful—how, after all, can we complain of this in him? He shows thus what he expected of us; and reminds us of our law. Let us render thanks to him who points out to us the beam in our own eye. Hardly does a man hold to a truth without taking advantage of it to scorn the other truth; you are right to notice this, my dear Gide, are you however sure that you, better than we, have healed up this wound? Or will you tell me that the Catholics, because they possess a very much

[1] As a matter of fact, it was not long before André Gide was disappointed, and said so.

[2] It is known that the feeling of the people has made it necessary to discontinue this propaganda since Russia entered the present war. (1943)

greater truth than other men, are also the most inclined to scorn the truths which are not their great truth? Well then? Doubtless it is so with us bad Christians, mediocre Christians. But after all it is precisely the truth that matters, and not we.

And if we were good Christians (there are some—they are the Saints), we would know that it is not we who possess the great truth, but it which possesses us; it does not belong to us, we belong to it. It loves, it preserves, it avenges, it illuminates and vivifies all truth. A Catholic ought to find singular delight, the pleasure of an angel, in rendering to his good enemies, to those friends of his, his enemies, a full and overflowing measure of justice, in recognizing in them all the good and all the true, all the signs of light enough which his God Who makes the rain to fall on the just and on the unjust manifests in all of us His generosity and His sovereign dominion.

But we must come back to our theme which concerns the moment 1935. Whatever may be its significance in regard to Gide as a person, the fact remains that his adherence to communism is a very remarkable symptom of the primacy everywhere exercised at present by the social, and of the renunciation of art before the anxieties and anguishes of the present moment.

The history of the surrealist movement invites one to a similar conclusion. Despite some useless spurts of liberty, held by a hand of steel André Breton is also ending up in revolutionary politics, and he is now obliged to ask of dialectical materialism, and of a Marxism understood withal in a more or less orthodox fashion, the bitter satisfaction of that carnal appetite

for the absolute and for purity, which a faceless angel dressed in tinsel was stirring up in his sufferings.

Like all that opens a breach, even if it be on the side of night, in the walls of *this world,* surrealism has had more importance than its exterior manifestations would suggest, for the historiographers of this same world; and did it not have in its luggage a torn piece of the mantel of Rimbaud? It has, for a moment, occupied in France the active edge of poetry; its revolt, its will to deliverance, the despair on which it nourished itself, brought it a measure of greatness. And what made it succumb so quickly was not so much its blasphemies, nor its fury against all which in man derives from the image of God, nor the literature (anti-literature) that infested it, but its spiritual inconsistency. Nothing was more childish, more armchair braggart than to ask of the methods of a police inspector, of a somnambulist, and of a professor, mistaken for the arcana of Physical Science, a so-called exploration of the abysses of the soul and a capturing of poetry. Is it astonishing that these explorers fished up the larvae of a Freudianism already become a subject for text-books and doctoral theses, and obsessions whose discouraging vulgarity could hardly be dissimuated by a very bourgeois refinement of aestheticism? As rich in talent as it may be, Dali's painting appears from this point of view a very logical outcome. If an Eluard, because of the force in him of a native gift, and of pain's sense of touch, and of much intelligence too—and if others, through the fortuitousness or the catastrophe of some singular disintegration—truly reach in passing the savage heart of poetry, it is in

spite of the surrealist system and procedure, and because through dissolution itself the arrows of being find an issue. Surrealism as a system has killed poetry. After all, it had always detested poetry, while tormenting it with impossible demands.

It seems as if God alone keeps alive in certain hearts, which are made by religious inspiration more attentive to the mystery of the created, the search, at the prow of time, for an ever new dialogue with the gods. For the moment, social problems have taken the place of poetry.

I mean of course that poetry is preserving for itself great witnesses. But the work of Claudel, like that of Eluard or Reverdy, of Cocteau, of Max Jacob, of Jammes or of Supervielle, this work surely suffices unto itself! It does not open up a new epoch.

Likewise, if a Jouhandeau continues to be occupied with the universe of the soul, and knows it only, and tears himself on the perfidious snags of its metaphysical caverns, if in certain books of exceptional significance his perfect art, to which some unknown regret gives so much cruelty, projects over the spiritual realities the astonishing light of a dizzy theology, he is certainly alone in conducting such a rare exploration, and has neither followers nor companions.

The novel poses wholly different questions, which I do not here touch upon. For it, the "knowledge of man" is, if I may so put it, a vocational task, but with Mauriac as with Malraux, with Green himself, the question is that of a *moral* knowledge rather than a *poetic* knowledge.

I am not unaware, on the other hand, that a certain will to regeneration by contact with the earth and to rediscovery of the natural sense of the simplest things born to existence (and already marvelous in that way), is appearing at present in many people. Of course I am not speaking here of what is called populism, which to my mind hardly exists. I am thinking rather of a sort of sturdy realism, a kind of reaction of the artisan's art as against the poet's art.

A sane reaction, perhaps; but a regression, unless it is preparing poetry's future counter-attack. Surrealism has gone astray on a dangerous presentiment, not in itself deceptive. Poetry does not deceive. In Joyce also this presentiment can be recognized. An art delivered from the ribbons and the skeletons of a language-factory adapted to the most superficial needs of the human being, an art that passes beyond success and the well-made, beyond the measures of man, and that jumps "out of its shadow— into its sun," what would render life tolerable ,as Saint Theresa said, precisely in regard to poetry) if not hopes of this kind? It is certainly permissible to think that in the use of signs and forms, and in the universe of poetry, man has before him no fewer secrets to discover than in the world of the sciences and of the knowledge of nature.

*

In the hollow of humility a painter meditates and gazes, he sees the vines that God has made, the olives, the nettle trees, the bulls, the unicorns—the moors and skies of Brittany—and the labors and movements, captured in slow-motion, of men whom

God also made; what he receives through his eyes falls into the silence of a fervent lake of contemplation and vegetates slowly until its resurgence in a work capable of acting as a talisman that would bring peace to the heart. By virtue of religious respect for things, but which would not suffice without a depth of soul, Jean Hugo reconciles the sensibility of our time, and all that enchanted us in Henri Rousseau, with the lofty and grave purity of inspiration of the primitives and the Chinese.

II

But it is of music, and of poetry, that I plan to speak.

Nowhere better than in music does there appear to the philosopher the very mysterious nature of the creative idea, or factive idea, that plays a central role in the theory of art. A pattern, as the scholastics said, *id ad quod respiciens artifex operatur;* that which the creative spirit looks at within itself in order to bring the work into existence. There is nothing truer, but, as with many a scholastic formula, there is nothing easier to kill while believing that one understands it. To academic thought this dictum would mean that the operative idea is a model which the artist carries in his head and sees there ready-made, and of which the work is to be the *copy* or the portrait. This is to make of art a cemetery by definition, a cemetery of imitations. For every copy (I do not say every image) is imitation, without form proper to itself nor formative in itself, of a thing, I say, formed from within, by its form or its soul.

And likewise in the ethical order, the academicism of virtue, which asks of the human being to make himself into the *copy* of an ideal, changes moral life into a cemetery of lies; in the end the ideal will have duped the conscience, and made of every act an hypocrisy: with no other way out than the escape of the unhappy Jean-Jacques into the dream-world of his *inhabitants.* Counter-trace your ideal as much as you wish to, construct, have recourse to compass and to tape-measure, you will be still an imitation; there is no tracing in the world of God. To imitate the Saints is not to copy an *ideal,* and it is not to *copy* the Saints. It is after their example—and by allowing as they did Another to conduct you where you do not wish to go, and love to con-figurate you from within into the Form that transcends all form —to imitate the Saints is to become, precisely, an *original,* not a copy; to imitate the Saints is, like them, to become inimitable. Invent something new? Invent one's self a new face? That's much too little for us, really—and still a lie. I mean for you yourself to become, at the very heart of your being, invention and novelty, the invention of Another and the new earth that He inhabits—for "He has one idea and who can turn Him?"[1] That this idea should be incorporated in you, soul of your soul, should quarter and dissolve you from within in order to remake you without your knowledge, and change you into one dissimilar to others, into a gulf of solitude no longer closed but open and peopled by the gift and thereby the more total—nothing less is

[1] Job—23:13.

necessary for love, and for freedom. *Non est inventus similis illi qui conservaret legem Excelsi.*

Such also is the work of art, in its manner and in the universe of production. It is not the copy nor the duplicate but, rather, the body of the artist's ideas. Astonishing correspondence of divine things! The work lives, outside of the artist, through an idea which is its internal principle of consistency and meaning, and which does not exist as idea except in the mind of the artist and separate from the work. And it is only when the symphony is made and finished that, in the mind of the composer, its creative idea is itself achieved. I mean as to the *expressibility* of this idea, as to the detail of its determinations and of its contours. A model to copy? The creative idea is an intuitive flash (given at one stroke but unexpressed, and without contours) in which the whole work is potentially contained and which will unfold and explain itself in the work, and which will make of the work itself an original and a model; incomparably more immaterial than is believed by academicism, such an idea is "a moment of intellection altogether spiritual and simple, which in regard to the work is transcendent and unlimited,"[1] and by means of which are formed the representations themselves, the conceptions and images that are, as it were, the raw materials of the work.

The creative idea expresses itself finally in matter, as the speculative intuition of the philosopher does in the concept or mental word. And in truth these are analogous: to perform the

[1] *Les Degrés du Savoir*, p. 791. Taken from an Appendix which was not incorporated in the English version.

inner word in the mind, and the work of art in matter. The majority go and buy this word ready-made in the department stores of language, and that swarm of birds which men exchange among themselves and which you see darkening the sky (this is called the intercourse of ideas) are stuffed words batted back and forth with rackets; lead weights are added by thinkers in the hope of putting out the opponent's eye, or bashing in his head. From time to time a word is really born, emerging from the invisible living waters where the ray of abstractive intuition meets the profound images and sensibility.

As for the creative idea, it appears to consciousness especially, in truth, as a decisive emotion, but an emotion transverberated by intelligence, a little cloud at first, but full of eyes, full of imperious visioning, charged with will, and avid to give existence; and if the affective tone imposes itself before all on our knowledge of ourselves, in reality what is of chief import in this intelligenced emotion is the invisible and intentional dart of intuition. Let us suppose even that it be pure intellectual intuition as in the case of the angel; in any case it has its structure and its contours expressed to the mind, its objectivity fashioned and uttered, only in the work itself that it produces outwardly; subtended by the concepts, born in the midst of them, even requiring doubtlessly, because of the conditions of mental activity in man, some vague obscure concept in order to come to birth in the mind, in itself the factive or creative idea is not a concept; it is an intellective gaze; it is an intellection having for *concept,* for intelligible fruit engendered—but exterior to the mind and born

of matter—the work itself that is made, the object not of knowledge but of creation, or rather, the object of creative knowledge which in its essence is forming and not formed, producing, and not produced.

<p style="text-align:center">*</p>

Where if not in musical creation could be found a better image of the creation of a world? Like the cantata or the symphony, the world was constructed in time (in a time that began with it), and is being preserved all the length of its successive duration by the thought from which it receives existence. There is nothing closer to the abyss of the created than the movement of that which passes, the flux, rhythmed and ordered, of the impermanent blossoming of a sensory joy that yields and fades away. Like the world and like motion, song has its countenance only in a memory; *si non esset anima, non esset tempus.* And no more than the flow of time is music in itself limited and closed. Why should the song stop? Why should a musical work ever finish? "It is not like a painting, there is no reason for it to finish . . .," was that a paradox? Let us say rather, that as the time of the world shall one day emerge into the instant of eternity, so music should cease only by emerging into a silence *of another order,* filled with a substantial voice, where the soul for a moment tastes that time no longer is.

<p style="text-align:center">*</p>

And how find for uncreated creative knowledge a more instructive image than created creative knowledge? Just as, in His essence eternally seen, God knows all things, so in his

factive idea the artist knows his work in a fashion that may be called substantial.

However, have I not said that this existence-giving knowledge is itself not finished, in its representable detail, until the work is finished? Let us venture to say that in one sense the same is true for the divine knowledge. For to give us some intelligence about the properties of the creative knowledge, called *scientia visionis,* it is not only the consideration of what is called God's "antecedent will" (by which He wills that all be good, all be saved), which we must add to the consideration of the divine essence infinitely transparent to the divine intellection, it is also the consideration of the "consequent will" of God, by which He permits the evil of the free creature—and by reason of what circumstances, if not of the refusal brought about by the creature? I mean not only by reason of the general possibility of refusal included in created liberty, I also mean by reason of the initiatives of refusal which in effect emanate from it at a given moment?

If it is true that in the line of evil the creature is the first cause (deficient, not efficient)—first cause of the privation or nothingness that wounds a given moment of his liberty—then it must be said that evil cannot be known save in the same instant when it thus wounds existence, when the creature escapes voluntarily from the influx of being and goodness that descends from creative love:[1] and it is because time is present in its entirety

[1] The good also of the free creature cannot be known save in the same instant when it is willed, but for another reason, because in a general way the constellation of all the created causes is incapable of giving fore-knowledge with certitude of the act of free will, which as such depends only on the will itself and on the first cause.

at the immobile and eternal *nunc,* that from all eternity, the free
absence, the voluntary non-regulation, the non-being that is the
root of the devious act accomplished by me at a given hour of
this clock of the universe or the atom, is and was and shall be
known of God.

Is this positing a determination of the divine knowledge by
the creature, I mean by the irruption of nothingness of which the
creature has the first initiative?—But do you then believe that
non-being is capable of determining? And furthermore do you
believe that created beings are for divine knowledge anything
else but a secondary term attained as a mere "material" or factual
datum, in no way formative or specifying? Are you forgetting that
only the divine essence is for divine knowledge a formal and
specifying object, and that neither the things (other than Him-
self) that God knows, nor the "decrees" nor the "permissions"
of His will have the slightest determining role in regard to His
act of knowledge? If we do not begin by recognizing the abso-
lute freedom of divine knowledge in regard to its created objects,
we had better not discuss these things. Even when it knows that
of which it is not the cause—evil as such—it is never formed by
what it knows. If its permissions themselves remain formative,
it is in this sense that divine knowledge still lays holds of and
assumes the initiatives of refusal of the creature in the designs
and the forms through which the torrent of being passes.

To say that God knows creatures in His essence, is not to
say that God does not know creatures but ideal models of them,
idea-pictures, Cartesian ideas, objects known in place of things,

of which things are the copy, itself unknown; it is not to make of the divine essence an idol of created things! The divine essence is not the image or the expression of things, it is the things that are themselves and in themselves a similitude and an expression of the divine essence. God does not know them in His essence as if in an image of them, but as in the infinitely transcendent intuition of Him by Him which is also the creative form of things.

In the pure flash of eternal and subsistent intellection which is His being, God knows possible things, He knows them and exhausts them, down to the undersoil of their own essence; and there, in that same flash He knows His "predetermining decrees"; to put it otherwise, He knows, among possible things, certain ones in so far as being freely willed and loved by Him, and thus in so far as existing, loving and acting; and in free creatures thus known exhaustively in their creative idea, and who are before Him like gods of "down below" because He has permitted them to refuse His love if they so wish, He knows the nothingness which they are able to "make" without Him (and only without Him)[1] and which they are making at a given instant on their own initiative, and by which they slip away from Him, fissure their being (and where indeed would He know evil, if not there where, negatively, it takes form—in the good that it wounds?) Thus God knows, by His knowledge of vision, evil—or rather that free non-attention to the rule of action, that pure and very secret "nihilation" which is the metaphysical root of wrong action

[1] "Since me *nihil* potestis facere." Joan. XV:5.—See *Saint Thomas and the Problem of Evil.*

—God knows evil in the acting creature himself, whom He knows—insofar as existing and freely acting—in the fires of creative love, and—in regard to his nature and to the abyss of his possibilities—in the consubstantial light of the Uncreated essence. Thus, in the light of what God Himself is to Himself, in the very experience of His own beauty and goodness, created things are known by Him and touched by Him without touching Him, to the profoundest depth of their being and of their non-being, to the furthest depth of the goodness of their very being (*et erant valde bona*), to the furthest depth of the sweetness of the good, or of the bitterness of the evil of their very doing.

*

As organic life is a growth of being which is constructed through victories and ruins, as mystical life is a passage constantly accelerated across the squalls of light and of night—so too the life of the creative spirit is a strange experience of growth and deepening—of course I am speaking of something wholly other than the perfectioning of technical knowledge and of skill; all is danger in this growth, but the worst danger is that of refusing it.

What is it, definitively, if not a progress in the realization of the metaphysical relationship, pointed out just now, between the creative human idea, in spite of all that it drains from alien servitudes, and the creative idea *par excellence* which is all liberty with regard to the object—formative and not formed? By nature the human creative idea depends in a humiliating manner upon the exterior world and upon all that infinite mass of forms and

beauties already made; and furthermore upon all the store of
what the generations have learned; and upon the code of signs
in use in the tribe; and upon the very rules for the fabrication
of the object (insofar as they are yet distinct from the creative
idea itself). It has need of all these and all these are alien to
it. While purifying itself it must subject all these to itself: sub-
ject them, therefore separate itself from them; *segregatus ut im-
peret.*

The movement of operative spirituality which is the essential
of the creative idea, *as such* is free of all, and receives nothing
from anything nor from anyone (save from the first Poet), in
order to form the object uniquely to its own resemblance. This
movement must constantly increase; likewise will the night in-
crease, sometimes transluminous and sometimes shadowy; like-
wise will solitude be brought about; likewise—uprootings, rup-,
tures, a destruction that would be universal.

It is understandable that there are grounds for hesitation.
When the heart is not rich in powerful constellations, when it
is not a universe in itself capable of holding its own before the
universe, then the ravages of the spirit will be merely destructive
and devouring, there will be nothing other than destruction.

But am I God, then, to make a divine work and to form with-
out being formed? Am I asked to create out of nothing? If
my work is a kind of concept or word that my creative intuition
fashions for itself outside of me out of the dust, what then will
it express?

In proportion as the artist approaches his pure type and real-

izes his most fundamental law, it is indeed himself and his own essence and his own intelligence of himself that he expresses in his work; here is the hidden substance of his creative intuition.

Is it himself, that is to say his states or his phenomena, his emotion as *material* to inclose in a work? This is the case for the commercial or idealistic corruption of art. I have just said that the creative emotion is not the matter but the *form* of the work, it is not a thing-emotion, it is an intuitive and *intentional* emotion, which bears within it much more than itself. It is the self of the artist insofar as it is a secret substance and person in the act of spiritual communication, that is the content of this formative emotion. It has been written[1] that vulgarity always says *I*: it says *one* also, and this is the same thing, for vulgarity's I is nothing but a neuter subject of phenomena or of predicates, a subject-matter like that of the egoist. But in an entirely different manner poetry likewise always says *I: "my* heart hath uttered a good word," "vivify me and *I* will keep Thy commandments . . .," poetry's *I* is the substantial depth of the living and loving subjectivity, it is a subject-act, like that of the saint, and likewise, although in another fashion, it is a subject which gives. The art of China and of India, like that of the Middle Ages, shelters itself in vain behind the rite or the simple duty of ornamenting life, it is as personal as, and more personal at times than that of the individualistic Occident. The more or less rigorous canonicity of art is here a secondary condition; in the days of old it was a

[1] Cf. Lionel de Fonseka, *De la vérité dans l'Art, dialogue entre un Oriental et un Occidental,* Paris, Chitra, 1930.

condition favorable for hiding art from itself. But the conscious-
ness of itself and at the same time the freedom which art acquired
a taste for, are fine dangers which mobilized poetry.

But man does not know himself through his own essence. His
substance is hidden from him, he perceives himself only as re-
fracted by the world of his acts which itself refracts the world
of things: if he does not fill himself with the universe he remains
empty to himself; thus it is not in the light antecedently possessed
of an intuition of the self by the self that he has his creative
intuitions, as have the pure spirits, he cannot express himself
in a work except on condition that things resound in him, and
that in him, at the mutual wakening, they and he come forth
together out of sleep. Hence the perplexities of the poet's con-
dition. If he hears the passwords and the secrets that are stam-
mering in things, if he perceives realities, correspondences, figures
of horror or of beauty of a very certain objectivity, if he captures
like a spring-finder, the springs of the transcendentals, it is not
by disengaging this objectivity for itself, but by receiving all this
into the recesses of his sentiment and of his passion—not as
something other than he, according to the law of speculative
knowledge, but on the contrary as inseparable from himself, and
in truth as part of himself; and it is thus to seize obscurely his
own being with a knowledge which will not come to anything
save in being creative, and which will not be conceptualized save
in a work made by his hands. His knowledge nourishes itself "on
a captive intelligibility"[1]: thus knowledge by affective connatural-

[1] *Les Degrés du Savoir*, p. 5 (*The Degrees of Knowledge*, p. 2).

ity, knowledge by resonance in subjectivity, is by nature a poetic knowledge, tending of itself to a work of sounds or colors, of forms or words. It is not without reason that the mystical experience, while incommunicable by its very nature (insofar as it is mystical) superabounds so frequently (insofar as it is knowledge by connaturality) in poetic expression. And as for the poet himself, it is not without reason either that he believes himself chosen to suffer more than other men;

J'ai l'extase et j'ai la terreur d'être choisi.[1]

As the mystic endures divine things, the poet is here to suffer the things of the temporal world, and to suffer them so much that he is enabled in expressing them to express himself. And when he is the most engaged in the act of spiritual communication, it is because he suffers still attentively an inexorable hand stronger than he, that passes and does not return.

<div align="center">*</div>

In order that there should grow unceasingly, conforming to its law, the life of the creative spirit, it is necessary that the center of subjectivity should continuously be deepened to a point where, in suffering the things of the world and those of the soul, it awakens to itself. In following this line of reflections one would doubtlessly be led to ask whether, beyond a certain level, this progress in spirituality can continue without, under one form or another, a religious experience properly so-called that would aid the soul of the poet to quit the surface-levels. Continuing at any price, refusing heroically to renounce the growth

[1] Paul Verlaine.

of the creative spirit, when such an experience postulated by the whole being had nevertheless been rendered impossible, wasn't this perhaps the secret of Nietzsche's disaster? In any case, what I want to keep in mind here, is that creation forms at different levels in the spiritual substance of the soul, everyone by this very fact confesses what he is; the more the poet grows, the deeper the level of creative intuition descends into the density of his soul. Where formerly he could be moved to song, he can do nothing now, he is obliged to dig down deeper. One would say that the shock of suffering and vision break down, one after another, the living sensitive partitions behind which his identity is hiding. He is harassed, he is tracked down, he is destroyed pitilessly. Woe to him if in retiring into himself he finds a heaven devastated, inaccessible; he can do nothing then but sink into his hell. But if at the end of ends the poet turns silent, it is not that there is ever achieved the growth of which we speak, it is not that of itself the song does not still ask to be more deeply born in him, less distant from the creative uncreated spirituality, archtype of all creative life, it is that the last partition of the heart has been attained, and the human substance consumed.

I have spoken of the poet, but of the one that every artist should be, and not only of the one who versifies. And here, again, it is the composer who in truth offers to the speculations of the philosopher a privileged experience. Less bound to the universe of human ideas and human values than he who creates with the vocables of the language of men, less bound than the painter and the sculptor to the forms and images of things, less

bound than the architect to the conditions for the use of the thing to be created, it is in the composer that are verified in the clearest fashion the metaphysical exigencies of poetry. So that when *he* falls short of them, the gap is most apparent. None other than a maker of operas could instruct a Nietzsche by so perfectly decisive a disappointment.

III

This question concerning the depth of the formation point of the creative impulse is of greater moment than all the others. A thousand other conditions are of import to the work of art, this matters above all. If the musical work of Arthur Lourié appears to me so rich in sense, this is because it seems to me that in no other artist today is the creative intuition born at a deeper level.

This is pure music, in truth, and this the purest music is at the same time the fullest. The philosopher finds in it an admirable illustration of the law that on condition of being born deep enough in the soul, and of being strong enough also to survive great perils, music or poetry is the most truly pure music or poetry (because the deepest level where it generates is a level of factive spirituality, of the spirit of music or poetry), precisely when it abounds with human and divine sap (because to be hollowed out to that point, the soul must have suffered much from itself and from without).

Because art is, also, spirit in the flesh, from the time it becomes conscious of itself it begins to suffer from the torment of freedom. Is it too not called to a certain deliverance? Being the

quintessence of the energies of the created, is not art engaged
in the travail of parturition like all creatures? The unhappy
epoch which is passing to its end under our eyes was conscious
of this vocation, and on that account it moved us. But how badly
it set about its work! A great poet of whom "stupidity is not
the strong point"[1]—was to place a feeble and dejected hope in
that sovereign art of dodging all that is most dear which has
always been the refuge of the classical French spirit. Both the
fear of the soul and the search for a compensating victory, of an
illusory eternity in the region of surfaces unfailingly arranged,
and the irremediable humanistic and Jansenistic dualism in
the classical spirit, rightly indicated by Charles Du Bos[2]—
a spirit which is altogether secularized nowadays and emptied of
substance—at last could not but reduce poetry to the impeccable
and delectable form of an absence. It is also, despite appearances,
in the region of words and mechanisms of expression (in seeking
this time to lay bare their subconscious origins—but to destroy
a machine is still to mechanize) that the surrealists have searched
for freedom. Dissimulated by a somewhat suspicious fervor for
mystery, it is still a taste for Cartesian experimentation that was
at work. They failed to produce a composer.

It is in music that poetry had its best chance. It sought with
more sensitive antennae; it touched several times what can hardly
be seized.

Debussy or music rediscovered,[3] yes, that was a first deliver-

1 Paul Valéry.
2 Cf. Charles Du Bos, *Approximations*, VIe série.
3 Cf. Louis Laloy, *La Musique retrouvée* (le Roseau d'or), Paris, 1928.

ance; what a marvel! Wrung were the necks of eloquence, of
mystagogy and magical pretensions; creative force and humility
found once more the genuine conditions of art, opened the foun-
tainheads of the working intelligence, broke the rules of the
schools, restored to the work its truth as a fruit spiritually ripened
for delectation. It was a deliverance however of art still more
than of poetry, which remained too closely linked to psychology,
to affective appearances, diluted now and then in the too fleeting
flow of an emotion that did not reach the soul. With the excep-
tion of some penetrating artists, learned and sensitive like you, my
dear Roland-Manuel, the experience of Debussy did not deliver
up its secret; and a work of genius the particular tendency of
which was directed toward factive objectivity, was, however, to
deceive, and to appear to surrender to the influence of sentiment.

The work of Satie seemed less great, his lesson went further;
it was the lesson of a Socrates maliciously the awakener of virtue,
troubling bad consciences and pricking good ones, he cleansed
music of all pretension and all pedantry, he profoundly purified
it, I think that in this order of the purification of means he de-
scended much deeper than Debussy; but it was still above all a
purification of the virtue of art, the modesty and the dissimula-
tions of his irony are from this point of view significant indeed;
poetry, and of what freshness, slipped slim and disguised, through
the half-open doors; she was there, admirably living and viva-
cious, along with tenderness; constrained however, shy as a beg-
gar-woman, she waited her turn. It is not to calumniate Satie's
successors to avow that in what concerns them, that turn has

rarely come about. After brilliant promises, and a little more than promises, the mechanics of address, of intelligence and taste began again to deal out surprises; the monotony of this exercise was to take on quickly a fatal aspect. The most certain talents, and God knows if they are numerous in our time, do not succeed in breaking the charm. Fallen into the inertia of a new formalism —stopped short on another route by the great experience of Stravinsky, which leaves nothing to be done where it has passed —or shaken by tentatives, sometimes astonishing, of galvanization—modern music finds itself once more in a critical phase, which might seem without issue.

From his uneasy retreat in the Alhambra of Granada, a recluse burning with ardor and faith has however shown the way. Harsh and knowing as is passion, discreet, secret, precise, and little by little transfigured within the deserts of prayer, the song of Manuel de Falla makes an eternal spring gush from the rock. At first attuned to the violence, after all a little thin, and close to the picturesque, of popular melody, the De Falla of *Master Peter's Puppet-show* is now taming, like an ascetic speaking to the birds, the universe of poetry. Is he too exceptional a composer to be made much of as an example by the philosopher seeking to note the wind-shifts of the contemporary spirit? Another solitary answers him, whose example is also significant.

I do not know whether our time is disposed to receive what Lourié brings to it. I know well that he brings it a delivered music.

Others[1] have retraced the singularly instructive curve of his experiments and researches since the time of the refined Futurism of the circles of Petersburg and of the manifesto of the *Spontaneous Spectre.*[2] What I wish to stress here is the force of *traction,* if I may so call it, and of enfranchisement, of such a work. It draws to itself and reassembles nearly all of what the music of our time has sought, and not only music, but poetry too, revolution, all that belabors our culture in the nervous centers of its pain. And now we see all this assembled booty (with all the armaments soon mastered of the technique and sensibility of our time) on which falls an unknown fire, beginning to throw up its highest flame.

Nothing makes more manifest the laws of growth which we have been discussing. Please don't take what I am saying as a sign of a one-track mind. I am rather embarrassed, so precise is the confirmation, to have to state that the great influx of the soul and inspiration which is renewing music today through the invasion of a murmur coming from the depths of substance, through a small cloud on the horizon which is to drench with a rain as fresh as fire the energies of the creative intellect, was produced in Lourié at the same time that another breath, this one contemplative, came to intensify the vital unity in the depths of a spirit long since religious.

[1] Cf. Boris de Schloezer, *Courrier des îles,* no. 4, July 1934; Henri Davenson, *Esprit,* February 1935.
[2] (1914). Lourié there recognized as principles special to music: "(1) The elimination of linearity (of the architectonic) by means of internal perspective (the primitive synthesis), (2) The substantiality of the elements." Since then he has taken more cognizance of the importance of construction.

It has been said of the music of Lourié that it is an ontological music; in the Kierkegaardian style, one would say also "existential". It is born in the singular roots of being, the nearest possible to that juncture of the soul and the spirit, spoken of by Saint Paul. Ontology as metaphysical knowledge is at the highest degree of abstractive intuition; but as for poetry, on the contrary, the more ontological poetry is, the more nearly does it gush from the impenetrable recesses of individuality, I mean the individuality of that spiritual soul one in substance with the flesh. And it is thus that it gives to the work produced the most powerful though still concrete charge of universality. If it is true, as I remarked before, that a resonance of the universe in the creative *self* is required by the operative idea, this contrast is easily understood. By the same token we can explain certain errors of philosophers who demand for their philosophy the privileges of a knowledge reserved to the composer, the painter, the poet.

"Ontological" music is "erotic" music—here again I am speaking Danish—I mean that it owes its substance to the Eros immanent in being, to that internal weight of desire and regret which all created things bemoan, and that is why such music is naturally religious, and does not entirely waken save under a touch of the love of God. Finally, it does not advance in the fashion of a horse or an ox, a snake, a bird or a projectile, it advances—for being is of itself transcendentally true, and reflected or reflectible in intelligence—by a movement of organically related words and responses and, as it were, of intelligible echoes; to put it another way, in the fashion of a dialogue, in the

fashion of that inner dialogue by which we converse continually
with ourselves or with God. It is in this sense (and without the
least reference to any logical play at all of thesis and antithesis)
that one of Lourié's works is entitled *Dialectical Symphony*.
There is indeed found in him, though he is of the spirit rather
than of the word, that characteristic of substantial conversation
which is carried to the highest degree in Mozart, angel of the
word.

It is, as I see it, with the *Liturgical Sonata* that the period
opens in which Lourié's art attains its plenitude and verifies in
an unimpeachable way the Pauline axiom—where the spirit is,
there is liberty. In the *Spiritual Concerto* the specifically religious
music, free of all traditional form, rediscovers, together with its
essential inspiration, an astonishing spontaneity. The *Dialectical
Symphony* is also religious but in an entirely different manner,
and in the absence even of any Christian theme: by the lineage
of the work alone. Thus it answers to what one could call a
religious sense of profane existence. The rhythm beats like the
heart of the great night, with a vital inexorable necessity; the
song traverses, envelops this night like a gaze that is contained
by nothing, like a love that makes the law, that *is* the law. Along
with the *Festival During the Plague* the same spiritual sense
penetrates to the heart of the perversity of the creature, of the
too much cherished delicacy of his delectations and his nostalgia
before they see rising over them the tranquil wings of death; the
profound Baudelairian affinities of Lourié, what there is in him
of dandyism and cruelty, but broken by what sweetness, appear

with a singular intensity in this admirable festival of the agonies of our world. Now what strikes me here is the progressive stripping and sharpening of intuition in the course of these three great works, which had logically to be born in this order, and in which the creative gaze becomes more acute as the object itself is more somber. But then it happens that the most recent work, at the date of writing, a song for two voices, a setting for a religious poem, *Procession,* is nothing but pure humility and fidelity, a perfect freeing in the movement of the soul, advancing to give itself.

<div align="center">*</div>

Is it another effect of that analogy in spiritual position with Baudelaire of which I have just spoken? I find in Lourié's work an aspect that I can only characterize by taking the risk of saying, for want of better words, that there is in this music "magic"— this being a dangerous word, a dangerous and desirable thing, it is proper to make some reflections on it.

All works of art are made of body, soul and spirit. I call *body,* the language of the work, its discourse, the whole of its technical means; *soul,* the operative idea, the "verbum cordis" of the artist—it is indeed born of the abundance of the heart; and *spirit,* the poetry.

It goes without saying that the body is the instrument of the soul. But I think—after all, the definitions of words are free— that there is "magic" in a work when the spirit transcends the soul, is in a way separate from it—like the *Nous* of Aristotle that entered by the door—and when the soul and the body find them-

selves in regard to the spirit as it were annihilated, I mean to say they become together, the soul like the body of the work, the pure *instrument* of an alien spirit, a sign through which passes a superior causality, the sacrament of a separate poetry that makes a game of art.

And what is there to say, now that we are furnished with these notions? We will first remark that there are (because beauty is a transcendental and analogical thing) three almost independent lines, if I may so put it, along which aesthetic emotion and admiration can rise; for a work can be beautiful through the body, or through the soul, or through the spirit (which is to say, poetry). And there is a fourth line which is no longer precisely beauty, but grace, in the sense in which Plotinus said that grace is superior to beauty; and in this line it is the magic of the work that is important. It is good to find here again the old master of magic of the Enneads. His teaching is uncertain when he proposes to conduct us to mystical contemplation and to introduce us to divine things; but if it is removed to the region of the things of poetry and beauty, its true force is then assumed. It is there Plotinus must be listened to.

After this I have no intention of proposing classifications or of undertaking a distribution of palms; moreover, certain work without magic can be more beautiful, greater and more accomplished, and richer in poetry than other work that is endowed with magic; it does not seem to me without interest, however, to test in the contact with experience the value of our instruments of prospection.

Fearing to lay a parricidal hand on the greatest of musicians, dare I say that there is little of magic in Johann Sebastian Bach? Yes, I shall say that this most sublime of music, this mother-music, is a music without magic: in Bach (and this is perhaps the secret of his power and of his fecundity), the spirit and soul are but one—the poetry of the work is consubstantial to its creative idea, which is not instrument but queen and goddess always. That is why the music of Bach prays with a great vocal prayer that is elevated to the contemplation which mystic theology calls "acquired contemplation"; it does not pass the threshold of mystical or infused orison.

The danger of magic arises from the fact that it is the gift of an order exterior or superior to art. He who has it without having sought it receives something from heaven or from hell —something difficult to bear, and which exacts an art strong enough to obey. He who seeks it inevitably alters his art, fabricates counterfeit money. Wagner lived only for magic; if we except *Tristan,* there is no magic in his music, not even the shadow of black magic—only the frauds and the drugs of a head drunk with science and genius.

The case of Satie is the reverse. Through the passion for probity, he detests, he excommunicates in himself all possible magic, he ferociously cleanses his work of it. Repressed, magic then disguises itself in the queer taste for mystification that disarms the enterprises of mystery, and that protects the ironic snows of a virgin music.

With Stravinsky the spirit or poetry of the work is not con-

substantial to its soul, but transcends it. But it is the spirit proper
to the composer, his dominating intellect, his own will. Thereby
it is understood how, the more he becomes himself, the further
he removes himself from magic. Compare the *Rites* and the
Wedding, where so many spirits of earth and of the waters still
haunt him, to other masterpieces like *Apollo* or that *Capriccio*
of which the brilliant poetry depends in its entirety on the made
object.

There is no magic in Beethoven; and yet who makes himself
loved better than he? Different indeed from Wagner, he does
not seek for magic; how resist this great heart that gives itself,
spirit and soul confounded, and which supplements a certain
want of the workman's invention by the generosity of his personal
substance dispensed without measure?

There is magic in Schubert, in Chopin, in Moussorgsky.
Magic is not always white. The magic of Lourié rises from the
shadows of the human depths traversed by the pitiableness which
assumes everything from a sort of catastrophe of being which
has all the weight of tragedy but whose character, properly tragic,
that is to say hopeless, remains problematic and so to say in
suspense, because of the face of God who passes through the
doors. His music, when it prays, crosses the threshold of super--
natural orison. The marvel, with him as with the other princes
of magic is that magic makes stronger and more dense the
art through which it passes, which obeys without ever bend-
ing. The magic of the chief of princes is an angelic magic—I
do not say that with Mozart an innocent angel is alone at work;

in this miracle of heroic childhood the cruelty of the child and the angel, a murderous grace, traverses at times the transparency and lucidity of infused knowledge, of the infallible play.

There is finally a sacred magic, the altogether white one, which has its source in the unutterable desires of the Holy Ghost, it is the magic of Gregorian melody. But it belongs to another universe.

<p style="text-align:center">*</p>

To recognize certain families of spirits, other principles of differentiation could be sought, drawn chiefly from the analogy of the world of art with the world of moral life. In certain of these spirits, the virtue of art appears to be more akin to prudence, in others to contemplation. Here are two families which hardly understand each other, here as elsewhere the prudent one dreads the contemplative and distrusts him, sometimes feels resentment against him. Like the old Descartes, Péguy, Rouault, Satie are prudent; whence circumspections, susceptibilities, fears, and the passion for admirable invention, for the good turn of genius brooded on in solitude. Bergson or Léon Bloy, Lourié, Jean Hugo are contemplative, they have an unconstrained manner, exigencies and detachment, the luck or the mischance of the privileged; their fortune or misfortune depends upon a transcendental, on which they have gambled.

<p style="text-align:center">*</p>

Don't you think, dear Lourié, that there are strange correspondences between Music and Philosophy? Both, when their center is in themselves, are capable of speaking out and of going

whither they will, they attain their goal, they believe in themselves, they spread out their tails, like the peacock, with the apparatus of their fine techniques; they install themselves, they are installed.

We prefer that they have outside of themselves and higher than themselves (to speak truth, infinitely higher than themselves) the point of fixity to which they hold, the center of their vitality. This is less convenient for them, they can no longer believe in themselves, they are condemned to move constantly, to detach themselves, to deracinate themselves, they never finish starting, they have palpitations of the heart, they are properly speaking *eccentric* virtues. Well, they have a chance to see the country, and to live a little, and perhaps thus they will approach that "Love that we will recognize by the wounds that we have given it".

Their goal flees continually before them. The more they advance, the more they see it retreat, it is behind them that they would perceive their nearness to it, but they cannot turn their heads. With no shade of esotericism in them, they are nonetheless masked. What does this mean? They must follow an evangelic way, mask themselves with light and with simplicity, that is what obfuscates most surely the eyes of men. They must cross dangerous zones where the spirit of vertigo can seize them, before arriving there where there is no more path, but the great firmament—the freedom of the peaceful.